Legends, Secrets and Mysteries of Asheville

Legends, Secrets and Mysteries of Asheville

MARLA HARDEE MILLING | Foreword by Jan Schochet

Published by The History Press
Charleston, SC
www.historypress.net

Copyright © 2017 by Marla Hardee Milling
All rights reserved

Front cover: Cornelia Vanderbilt and John Cecil. *Library of Congress*; statue at Riverside Cemetery. *Marla Milling*; Vince Lombardi. *Heritage Auctions (ha.com)*; Mike Harris with guitar given to him by Elvis Presley. *KarriBrantleyPhotography.com*; aviator Amelia Earhart. *Library of Congress*; the Hope Diamond. *Smithsonian National Museum of Natural History.*

Back cover: Tintype that may be a rare photo of Billy the Kid. *Frank Abrams.* Background photo: A paper dress created by Mars Manufacturing of Asheville. *Marla Milling.*

First published 2017

Manufactured in the United States

ISBN 9781467135917

Library of Congress Control Number: 2017931820

Notice: The information in this book is true and complete to the best of our knowledge. It is offered without guarantee on the part of the author or The History Press. The author and The History Press disclaim all liability in connection with the use of this book.

All rights reserved. No part of this book may be reproduced or transmitted in any form whatsoever without prior written permission from the publisher except in the case of brief quotations embodied in critical articles and reviews.

Dedicated to those who are no longer on this earth but who greatly shaped my life and instilled in me the confidence to pursue my dreams.

My mother,
Geraldine "Gerry" Shuford Hardee

My maternal grandparents,
W.A. and Bessie (Garrison) Shuford

My maternal aunt,
Louise Shuford

My paternal grandmother,
Lucile "Lucy" Chandley Midyette Hardee

My maternal grandfather's brother and my great-uncle,
Ellis Shuford

My maternal grandfather's sister-in-law (wife of Adlai Shuford) and my great aunt,
Leah Shuford

A woman I always called "Aunt" and loved just the same as blood,
Bess Swicegood

Contents

Foreword, by Jan Schochet ... 9
Acknowledgements ... 13
Introduction ... 17

PART I: SECRETS AND MYSTERIES
Going Underground ... 25
Ghosts, Graveyards and Zombies ... 36
The Search for Amelia and Other Aeronautical Feats ... 54

PART II: HIDDEN TREASURES
Time Capsules ... 63
Secret Stash ... 72
One Man's Junk ... 82
Flea Market Treasure ... 90

PART III: LEGENDS OF THE RICH AND FAMOUS
Rock-and-Roll Fantasy ... 107
The Hope Diamond's Asheville Connection ... 114
Biltmore Mystique ... 130

PART IV: SURPRISING CREATIONS
Beatty Robotics ... 145
Groovy Garb ... 154

Contents

Bibliography 163
Index 167
About the Author 171

Foreword

You're one of the smart ones. You, with this book in your hands.
 When most people visit old places, go to new places, even pick their heads up out of their daily lives to look around their own place, they rarely do what you're doing. Reading about that place.

There's something that stealthily but solidly connects a person to a place when they spend time getting to know about it. And it doesn't have to be much time. It can be as simple as getting your hands on one or two good books.

Me, I used to just show up and learn while there. "Flippant" would be a good descriptor.

As a college student, years ago, before there were many study-in-Europe experiences, I ended up in England one summer and hadn't done any research. I loved the Beatles. So, what more about England—over and above the fan magazines I'd read as a teenager—did I need to know?

There's something to be said about just going somewhere and "breathing in the atmosphere." But you won't learn the nitty gritty What-the-Locals-Know by simply showing up.

I was amazed when I learned two of the twenty-four kids in our group had actually researched many aspects of Oxford, where we'd be spending four weeks. And all of England, where we had two more weeks to roam.

Those who'd pre-discovered always came up with the most interesting adventures for us to charge right into.

That was decades before the Internet, when information was not as easy to find as it is today. Although there's a ton of information available now, much

of it is repeated content, often courtesy of local chambers of commerce and visitors' centers, repackaged by writers who don't even bother to visit the places they're writing about. Because you actually can put together articles from what's already out there.

But…it takes digging to find the Good Stuff.

It takes someone who knows where the bodies are buried, sometimes literally.

It takes a native of a place oftentimes—actually almost all the time—to know who to talk to and what to ask.

It takes persistence, pluck and good old pavement pounding to find the scandalous details. To find what isn't so readily available. To find the Best Stuff.

You're in luck.

Because Marla Hardee Milling has already done that work.

In fact, this is the second book that's a result of her deep digging into some of the most interesting, unique and unusual facts surrounding Asheville, the Land of the Sky.

I met Marla when she was writing her first book, *Only in Asheville: An Eclectic History*. She e-mailed me, asking to talk about the 1980 organization Save Downtown Asheville.

That was a story my friends and I had lived, but one that receives little press these days. So, I was happy somebody, anybody, was interested.

Marla's an Asheville native like me. We grew up on opposite sides of town with about a ten-year age difference, so we didn't know each other. Yet when we met, we both felt camaraderie as natives of our suddenly fast-growing community. And we shared Asheville stories.

I learned Marla had not gone to seek her fortune in the Great Big World out there—she'd graduated from UNC–Asheville and went on to work at the local TV station, WLOS, for ten years.

That's where she'd honed her chops—being a TV news producer, a job in which digging quickly and actually finishing were important. She learned to work in the chaos of a newsroom, where facts were at the top of the list. And she was doing local news, where she got to meet many people involved in interesting, news-worthy situations and endeavors.

When we met, she'd continued that work by being a freelance writer for more than ten years, earning her living writing for local, state and regional newspapers and magazines, as well as national publications and websites.

Marla's ability to sniff out a story and write a printable article is top-notch.

She knows who to talk to and the questions to ask. Her interests lean toward the eccentrics, the unusual, the outliers. What I consider interesting.

Foreword

As for me, these days I often research before I visit a place. If I were visiting Asheville, I'd definitely pick up this book.

Now it's your turn to explore our city by tucking into *Legends, Secrets and Mysteries of Asheville*, discovering what many of the locals don't even know.

Smart. Very smart.

Jan Schochet. *Photo by Daryl Kessler, www. Riverview-Photography.com.*

JAN SCHOCHET, ASHEVILLE HISTORIAN AND INSIDER
"Mapping Life in These Hills,"
essay, *27 Views of Asheville*
Asheville, NC
January 2017

Acknowledgements

Go confidently in the direction of your dreams. Live the life you've imagined.
–Henry David Thoreau

I am so grateful to Banks Smither, commissioning editor at The History Press, for providing me with the opportunity to write my second book. Like the first—*Only in Asheville: An Eclectic History*—crafting this book has been a labor of love and the culmination of a dream to be a published author. I appreciate the patient guidance Banks has always offered to me as we've worked together from concept to finished project. I also appreciate the careful editing of Ryan Finn. Ryan also edited my first book.

My children, Ben and Hannah, deserve so much credit and love for tolerating my crazy schedules and fatigue as I have immersed myself in this project. My goals are always inspired by the two of them. They are my joy. I've also received great support and encouragement from my dad, Ray Hardee, and my maternal aunt, May Shuford. I would have never been able to write this book without the help they extend to me in all areas of my life. I love them so very much. Special thanks to my lifetime friend Donna Morgan Green, who continued to cheer me on with "you can do it," even when I felt I was running out of steam. I also offer thanks to my friend Suzie Heinmiller Boatright for taking my author photo and exploring parts of Asheville with me that I'd never seen before. And my appreciation goes to Sue Magley for daring to go to an Asheville séance with me. It's detailed in this book.

Acknowledgements

Life threw out plenty of challenges in the past year, and they pulled my focus at times from writing this book: my dad suffered a stroke (he's recovered very well), my daughter went through the intensive process of becoming a Rotary exchange student and traveled to Hungary for her junior year in high school, my son graduated from Asheville High School and I continued to fit a book into an already full writing schedule. This creation is proof, once again, that you don't need "time" to write a book. Not having time is simply an excuse some people give themselves. They say, "When I have time, I will do it." "Once my kids are grown, I will do it." But the time is always *now*. I had several people approach me at my Malaprop's book signing in July 2015 asking how they could write their own book. My advice: "Just start." If you are dreaming of accomplishing anything, just start.

One of the most amazing things that happened as I wrote the first book involved making new connections and new friendships. I didn't know Jan Schochet before embarking on the first book. Now I consider her a trusted friend and have deep admiration for her talents and her presence. She's an Asheville native, with ancestors who arrived in Western North Carolina (WNC) in the mid-1800s. Her parents operated The Bootery on Patton Avenue, and her uncle ran The Star Store. They later combined the stores into one building, with The Star on one side and The Bootery on the other. Locals began calling it The Star-Bootery, and the name stuck. Following graduate school, Jan returned to Asheville to open A Dancer's Place in the building her parents owned next to The Star-Bootery. She continues to own these buildings today, and unlike many out-of-town landlords who only see Asheville as a means to fatten their wallets with rent going to the highest bidder, Jan is devoted to offering space to local artists and shop owners who are truly invested in being a part of the community. She played an integral part in saving downtown from being gutted and replaced with a mall in the early '80s (see my first book for details on the Save Downtown Asheville campaign), and she continues to support the positive growth of Asheville. I am thrilled that she agreed to write the foreword to this book, and I extend to her my deepest gratitude.

The staff at the North Carolina Room at Pack Library deserves special recognition and my deep appreciation. They make research such an enjoyable process and have always been quick to field my requests and searches for information. Thank you, Zoe Rhine, Lyme Kedic, Ione Whitlock and Ann Wright. I am also grateful for the assistance of Gene Hyde, head of special collections and university archivist at D. Hiden Ramsey Library at UNCA, as well as the ongoing assistance of Marissa Jamison, public relations manager

Acknowledgements

at Biltmore Estate. Katie Wadington, executive editor of the *Asheville Citizen-Times*, did some extensive digging to come up with an archive photo that she then allowed me to publish in this book. I am very appreciative of her help. Karri Brantley also wins my thanks. She's a professional photographer who took shots of Mike Harris with the guitar gifted to him by Elvis. She has allowed me to use one of those pictures, and I applaud her generosity and her amazing talent. I also found out that Karri was a former tour guide for LaZoom and a member of the all-female sketch comedy troupe, LYLAS, when she lived in Asheville. She now lives in Michigan.

This book would not have been possible without those who so generously shared their time and stories with me. I am so deeply appreciative. The following is a list of people I personally interviewed for this book:

Christina Abrams	Debbie Ivester
Frank Abrams	Jim MacKenzie
Audrey Bayer	Lucy Menard
Bob Bayer	Chuck Rapp
Camille Beatty	Zoe Rhine
Genevieve Beatty	Billy Sanders
Robert Beatty	Jim Siemens
Mark-Ellis Bennett	Heather South
Dr. DeWayne Cecil	Gary Stephenson
Blaine Cone	David Voyles
Kevan Frazier	Chris Walker
Joseph Charles McLean Gregory	Joshua Warren
Mike Harris	Karen Yoder

As in the first book, I think it's important to point out the places where I conducted interviews, as well as spots where I wrote chunks of this book because all of it plays into the creation you are now reading. I conducted interviews at Asheville City Hall, the Western Regional Archives office on Riceville Road, the North Carolina Room at Pack Memorial Library, The Collider, Frank Abrams's bank (I won't name it for privacy purposes), Olive or Twist, Panera Bread, Byrish Haus Restaurant & Pub, Beatty Robotics garage studio, the Reynolds Mansion Bed & Breakfast Inn and the Reynolds-Oertling House, as well as others by phone. I spent time writing much of this book at home, but I also spent quite a bit of time writing in AMF Star Lanes Bowling Alley on Kenilworth Road (yes, it's a rare talent to tune out all the noise and chaos—something I learned how

Acknowledgements

to do from my WLOS days when the newsroom was filled with scanner traffic, news truck radio communication, various channels and feeds all sounding at once, and I still had to concentrate on writing), Atlanta Bread Company, the waiting rooms at Mission Hospital and even the waiting room at Great Beginnings Pediatric Dentistry.

Writing a book is definitely a group effort. Without the help, suggestions, stories, encouragement and time of others, this book would still be just a dream. Thank you all for helping to make it a reality.

Introduction

Synchronicity is an ever present reality for those who have eyes to see it.
—*Carl Jung*

I've always been intrigued by things that can't be explained, whether it's a feeling of déjà vu, a "coincidence" that seems touched by the hands of fate, a serendipitous encounter, the phenomenon of thinking about someone you haven't seen in a long time and suddenly hearing from them and even things that go bump in the night. I'm a lover of synchronicity, serendipity and all things paranormal. I do buy into the saying that "there are no accidents." We are all connected somehow in this incredible life experience, and I have found that Asheville has its share of strange and delightful stories of hidden surprises, intriguing personalities and interesting mysteries.

After writing my first book, *Only in Asheville: An Eclectic History*, which focuses on how Asheville became such a popular, quirky place, I naturally gravitated to digging a bit beneath the surface to find out more about Asheville's secrets, beginning with tales of underground tunnels. Joshua Warren had piqued my curiosity about the tunnels when I interviewed him for the first book. Starting with the idea of the tunnels led me to search out more unique stories, and many started appearing in the local newspaper. I read about the planned auction of a guitar that Elvis gave to a fan at an Asheville concert. Another was about a renovation team finding a secret stash of books and other items in an Asheville home purchased by a local attorney. Yet another was about another attorney who may have struck it rich by shelling out a few bucks at an area flea market.

Introduction

I discussed my new book content with my dad, who provided me another story. He said, "You should write about Senator Bob Reynolds's daughter, who inherited the Hope Diamond." What? I had never known this. How did I grow up in Asheville and not realize that an Asheville family had ties to one of the most famed gems in the world? That story is in this book and led to a wonderful friendship with Joseph Charles McLean Gregory, the son of Mamie Reynolds and the great-grandson of Evalyn Walsh McLean, who bought the gem in 1912 for $180,000.

Then there were stories that came up in random conversations. Leslie McCullough Casse, who wrote the foreword to my first book, told me about the paper dresses that Bob and Audie Bayer created at Mars Manufacturing. During an interview with Robert Beatty about his book, *Serafina and the Black Cloak*, he revealed that he and his daughters created a robotics company in their garage. And it was Jan Schochet, who wrote this book's foreword, who told me during lunch one day about pilfered books from George Vanderbilt's lavish library at Biltmore Estate. I investigated and wrote about all of these tidbits in this book.

One of the major lessons I've learned in my life as a writer is to never delay getting details on a good story. While writing this book, as I read or heard about intriguing people and events, I quickly picked up the phone and reached out to the person involved—in the case of historical information, I made a beeline to the North Carolina Room at Pack Memorial Library. I find that most people are more than happy to share their stories and their lives, and I am extremely grateful to those who let me interview them for this book.

Strangely enough, a surprising find found its way to me during the process. First, a short background story. A few years ago, I was digging through the bins at Goodwill Outlets on Patton Avenue (the same bins where another couple in this book found a treasure they auctioned off for a large sum). The bins are different from a regular Goodwill outlet store. Instead of having items arranged neatly on racks and shelves, items at the outlet are dumped into big bins and sold by the pound at the cash register. One day, I was digging through a bin of books. I picked up a journal, flipped through to find it filled and started to toss it back. I made a tossing motion with my wrist, but my hand couldn't release it. I couldn't bear sending someone's handwritten journal to ultimately be destroyed. I bought it and brought it home with a stack of other books.

It took several months before I remembered the journal. When I opened it, I found a name written inside. I Googled it to see if I could locate someone with that name and found the woman's obituary. The journal

Introduction

writer lived in Weaverville, and among her children was a daughter living in Marshall, North Carolina. I found Amy Gillespie on Facebook and sent her a note asking if she wanted her mother's memories. She drove to my house and picked it up, and we've been friends ever since. I've also become friends with her stepmother and dad, Linda and Jim Gillespie, and feel extremely lucky to know all of them.

Imagine my surprise when I received a note similar to the one I sent Amy. In early August 2016, a man from Georgia sent me a message through my writer's page on Facebook. He said, in part:

> *I hope this rather odd message reaches you. Recently, I've been going through my belongings seeing what to keep and what to throw out. One item I found was an old French textbook I bought years ago when I began collecting antique books. I was going to throw it out, but realized that it was inscribed with the name of a young woman, one who (rather charmingly) scribbled all throughout the book. I've just started researching my family's genealogy and I couldn't help but think how nice it would be to own something like this that once belonged to one of my ancestors. So I decided to do some investigating and find the closest descendant. That is how I came upon your Facebook. This book was owned by Lucile Chandley who attended Davenport College in Lenoir, N.C. circa 1931—I believe she was your grandmother.*

He included scans of the book cover and inside where she had signed her name. I immediately recognized my paternal grandmother's handwriting on the pages but was very surprised to see Davenport College under her name. I was only aware that she had gone to Salem College, so it was an extra bit of family history to learn about this. I've long been interested in genealogy and was thrilled with the discovery of her French textbook. Much of the family research on Lucy's side was very easy because she had documented how Rebecca Sevier, ninth child of General John Sevier, was her great-great-great-grandmother. I like going over to Sevierville, Tennessee, knowing that I'm a descendant, no matter how far down the line, of the man for whom the town was named. Sevier had a remarkable career, including six two-year terms as Tennessee's governor (1796–1801 and 1803–9) and three terms in the U.S. House of Representatives (1811–15). My Sevier line of ancestors moved into Madison County, North Carolina, in the early 1800s, with my great-great-grandfather Mitchell Chandley serving as sheriff for a time. Ancestors on my mother's side were in Buncombe County by the late 1700s, if not earlier.

Introduction

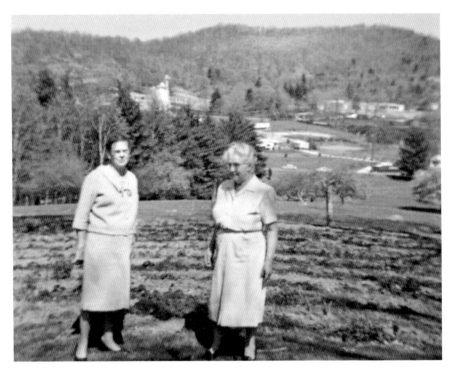

Leah Shuford (author's great-aunt) and Bessie Garrison Shuford (author's maternal grandmother) standing in front of the garden at the Shuford home in south Asheville. In the far left, you can see part of the Ball glass factory. Today, several businesses occupy the land where they were standing. *Author's collection.*

After my first book came out, I found that many people were interested in knowing more about the evolution of south Buncombe County, where I grew up and where my mother and her five siblings grew up. Today, south Asheville resembles an Atlanta suburb with its strip malls, big-box stores, chain restaurants and grocery stores aplenty. It's hard for newcomers to imagine the south Asheville I knew and loved, with its open pastureland, a community of kind neighbors and such a manageable traffic flow on Hendersonville Road that for entertainment we'd sit on the porch and count the number of cars that would drive by on sultry summer nights.

My maternal grandparents, W.A. and Bessie Shuford (affectionately known as Gan Gan and Granny), had about twelve acres or so fronting on Hendersonville Road, with pastures containing cattle and, for a time, my pony, expansive gardens and beehives. There was plenty of space to roam, dream, ride my bicycle, learn to plant, pick, string and can green beans, shuck corn,

Introduction

gather blackberries and pluck grapes from their vines, play hide-and-seek in the dark or pretend with my cousins that a fallen tree in the front pasture was a pirate ship. Pulliam Properties now has its office building in the center of what used to be the front pasture. My grandfather operated a Shell station on the corner of Mills Gap Road and Hendersonville Road (where Kentucky Fried Chicken is now), and my parents took over operations when he retired. I wish I could remember all of my grandparents' stories and their advice. I did, however, take note of their allegiance to their *Old Farmer's Almanac*, checking the moon signs and stages to plant their gardens, set fence posts, get haircuts and other things. My granny told me to never have a medical procedure (unless of course it was an emergency) done when the moon signs were bad. This advice has served me extremely well throughout my life.

Life in Skyland was idyllic, and if I could go back and change anything, it would be this: I would encourage my younger self to take a gazillion pictures of everyday life and write down *everything*. While I can't re-create all the stories I've forgotten from my youth, I do have an opportunity now to preserve some interesting stories connected to Asheville.

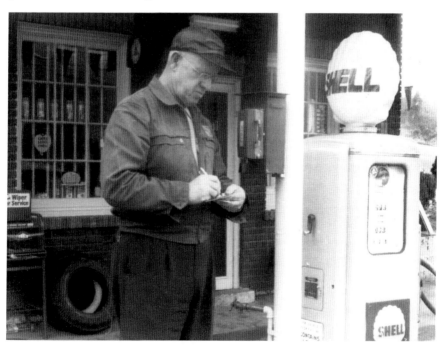

W.A. Shuford (author's maternal grandfather) at the Shell Station he operated at the corner of Hendersonville Road and Mills Gap Road in south Asheville. Today, a Kentucky Fried Chicken stands in its place. *Author's collection.*

Introduction

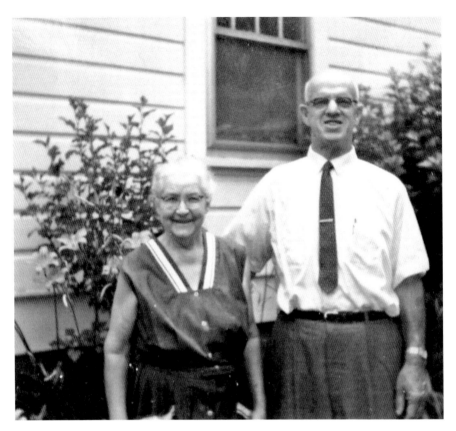

The author's maternal grandparents, Bessie and W.A. Shuford (Granny and Gan Gan), at their south Asheville home. *Author's collection.*

I've divided this book into four sections: "Secrets and Mysteries," "Hidden Treasures," "Legacies of the Rich and Famous" and "Surprising Creations." After my first book came out, many people quizzed me on how I decided who to interview and what to include. This also led to many suggestions of potential topics, which I always appreciate. Part of why I feel so pulled to write books about Asheville is the opportunity not only to help preserve stories of this marvelous town but also to write about the things that I personally find interesting. My publisher gives me complete freedom to choose content that I feel best illustrates the topic. Were there things left out that I wish I had time to include? Of course. Are there enterprising folks who deserve to be interviewed? Absolutely. But there has to be a stopping point in order to get a finished book on the shelves. I hope you enjoy the choices I've made on what to reveal this time about Asheville.

PART I
SECRETS AND MYSTERIES

Going Underground

There are mysteries that man may only guess at, which age by age they may solve only in part.

–Bram Stoker

A proliferation of rumors and secrets lurk beneath the streets of Asheville. While I'd be interested in hearing what the walls have to say in Asheville's historic buildings, I'd be more engaged listening to the whispers emanating from underground about what went on there in years past, as well as hearing about how all the tunnels are connected and who used them. Tales emerging from underground probably wouldn't be for the faint of heart—it was a place for the illegal smuggling of liquor during the Prohibition years, drug deals, prostitution and other sordid happenings.

If you've been around town long enough, more than likely you've heard some of the tales of underground tunnels. In 2010, famed paranormal investigator, prolific author and Asheville native Joshua Warren offered an "Underground Asheville" tour, but it was short-lived. "The bits and pieces of the tunnels that still exist are strewn beneath a variety of businesses," said Warren. "Coordinating with all those businesses to access their property was stressful, and by the time everyone got a cut of the money it wasn't a very profitable endeavor. We might have given this tour three or four times and that was it." The tour he developed with historian Vance Pollock included the entrance tunnel in the basement of Pack's Tavern, Rat Alley (between Patton and Wall Street) and a building across from Vance Monument that

once held Sisters McMullen Cupcake Corner. "In 2010, you could go into the bathroom at Sisters McMullen and find a door on the floor," said Warren. "If you lifted it and climbed down a ladder, you would find yourself in a sizable chunk of the underground system. They were using it as storage at the time."

Warren, who continues to operate Haunted Asheville Tours, said that the network of Asheville tunnels is now a hodgepodge of disconnected spaces. "Most have been filled in or sealed off," Warren said. "Many sections have just been assimilated into basement space by present-day businesses. There are stories about these sections being used for various purposes over the years. For example, at Vincenzo's [*this restaurant at 10 North Market Street closed in February 2015 after a twenty-four-year run*], they claim their section was used to store excess corpses during the Spanish flu epidemic of 1918."

"It is my opinion that the network downtown had a rough V-shape," explained Warren.

> *The bottom of the V was around Pack's Tavern. From the position of Pack's looking toward the Vance Monument, the left-hand side ran past the monument and down the left side of Patton Avenue toward Church Street. The right-hand side ran past the monument and eventually down the right-hand side of Patton. There were a number of branches and, of course, the main support structure directly underneath the Vance Monument where the old, underground bathrooms were located. It would make sense for the bottom of the V to be around Pack's for drainage purposes. The Vance Monument is over 2,218 feet elevation. Pack's Tavern is 2,180 feet. That's a difference of around 40 feet in a distance of just 585 feet.*

As to speculation that the tunnels led from Asheville's Masonic Temple to the Vance Monument (built by the Masons), Warren offered little confirmation. "As the owner of the Asheville Mystery Museum in the basement of that building, and as a Mason myself, I can neither confirm nor deny the truth of that rumor," he said. However, he alluded to the possibility of an underground tunnel between the two when he mentioned Tressa's nightclub, which is located on Broadway between the temple and the monument. Warren told me, "If you walk the streets of Asheville, you will occasionally see little glass squares embedded in the sidewalk—like outside of Tressa's. When you are under the street, these are like little skylights. I have been told they were used for lighting at chutes where coal was once dumped below for businesses to burn."

During his research, Warren commonly heard explanations that original maintenance and drainage tunnels were expanded into experimental tunnels for a subway. "We never found an official document to say this, but it would make sense considering the streetcars were viewed as a nuisance in those days when the lanes of Asheville were packed with pedestrians," said Warren. "During the prohibition, it would make sense that the status of those tunnels, or any extra storage space, would become privileged information. It is also a shady secret that a tunnel used to lead to a brothel below the Langren Hotel. When the hotel was demolished, so were the tunnel spaces." The Langren Hotel he referred to was built in 1912 at the corner of Broadway and College Street, where the brand-new AC Hotel stands today.

Getting confirmation of the tunnels from city officials proved difficult. Warren said:

> *I talked to Steve Shoaf, Water Department director, and he said he could not comment on this subject; that it is a Homeland Security issue to provide information regarding the underground infrastructure of any U.S. city. However, we heard of old-timers with the water department claiming there are extensive tunnels running down Charlotte Street with a significant entrance now buried under center field at the Martin Luther King ballpark. Supposedly you can climb a ladder down an eighty-foot shaft to access them. There are also plenty of reports of large holes opening up in the ground around the city. APD Officer Travis Duyck told me a sinkhole opened at the corner of Urban Outfitters and Pritchard Park in 2008. An employee named Arsenio, at the now defunct Fred's Speakeasy, talked about a weird hole opening in their floor once, as well.*

Pack's Tavern

Pack's Tavern was one of the places on Warren's tour that has substantial evidence of underground tunnels. It's actually two buildings—workers constructed the north building in 1907 and the south building in 1912. It formerly served as a lumber mill, a barbecue restaurant and an automotive store before becoming a tavern restaurant. Developer Stewart Coleman originally planned to demolish the building and put condominiums on the site, but when that plan fell through, he and his partners entered the

restaurant business. That decision also preserved a bit of Asheville's history. The basement features an entrance, with two heavy iron doors, leading to a tunnel system. Coleman died in 2012, but in September 2011, he spoke with UNC-TV; the segment is archived on YouTube. Regarding the extent of the tunnels, Coleman said, "They run even under the Masonic Temple and in front of the Biltmore Building. They discovered them in the park during revitalization. There was a series of four tunnels that crossed over each other." Running illegal liquor was thought to be the tunnel's primary usage. "It's the federal boys who were required to do raids," Coleman said. "They announced their presence, and it would allow the buildings to empty through those tunnels."

Warren pointed out another mystery found in the door leading to the tunnel at Pack's Tavern. There's a letter *G* on the left side and an *R* on the right side, but so far no one has figured out what they mean. "Could they be a reference to Gallatin Roberts, the mayor of Asheville who committed suicide in 1931?" asked Warren. Roberts was facing trial for banking law violations but adamantly denied involvement. In an article on the blog of the North Carolina Room at Pack Library, it was mentioned that a typed letter was found after his suicide. The last portion read, "I am guilty of no crime. I have done no wrong. My hands are clean. I look the whole world squarely in the face and defy any person anywhere to prove that a single cent of corrupt money or any other thing ever dishonestly touched my hands. I shall demand an immediate trial."

Underground Bathrooms

Many people who grew up in Asheville in the '60s can recall the underground bathrooms that Warren mentioned around the Vance Monument area. Racial division was in full swing, with signs denoting bathrooms for "Whites" and another sign reading, "Coloreds." I scoured through comments on the "You know you grew up in Asheville, North Carolina if…" group page on Facebook and found several threads recalling these bathrooms. One person detailed wide marble stairs leading underground, while another remembered having to put a dime in the slot on the doors or use a free one on the end that was much less desirable. Warren e-mailed some of the actual blueprints of the underground space at the Vance Monument, saying, "I can't say where I got them, but I doubt it has ever been published."

SECRETS AND MYSTERIES

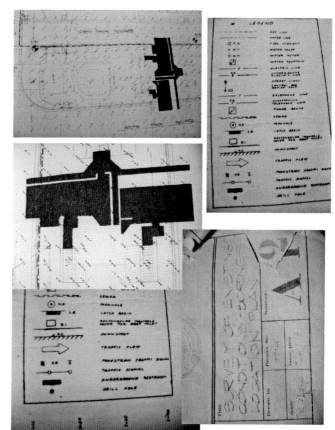

Right: Blueprint of the underground bathrooms at Vance Monument. *Joshua Warren.*

Below: A vintage view of Vance Monument in downtown. Look closely to see the entrances to the underground bathrooms. *North Carolina Collection, Pack Memorial Library, Asheville, North Carolina.*

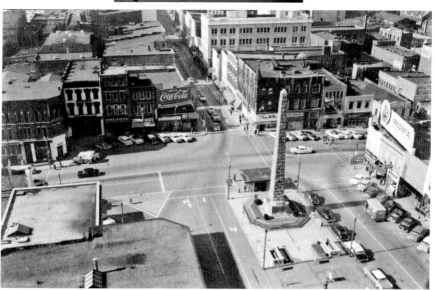

Asheville historian and author Kevan Frazier remembers going down into the underground bathroom area when his uncle was working as superintendent of the I.M. Pei building (also known as the Biltmore Building). "When they dug down for the parking deck during construction, they hit against the edge of those bathrooms," said Frazier. "They were using it for their planning room. I remember going down there, and that room was open. What I've always heard is that the bathrooms are still there. There was no reason to spend money to fill it in."

Frazier said he's heard that there's access under the block of buildings that house Posana, Rhubarb and The Noodle Shop restaurants that connect into those underground bathrooms.

As owner of Asheville by the Foot Tours, he's also well aware of the many legends surrounding the tunnels. "There's always been a legend of a tunnel between the Masonic Temple and city hall. I think that was a euphemism—that all the guys in power were part of Mount Herman Lodge, and people would say, 'It's like there's a tunnel between the Masonic Temple and city hall.'"

He also referred to Rat Alley, which ironically is a stone's throw from his latest business venture. In March 2017, Frazier and Cortland Mercer opened Well Played, a board game café, at 58 Wall Street.

Rat Alley

I began my own exploration of Asheville's underground on a sunny October day. My partner in crime, Suzie Heinmiller Boatright, and I ventured into the area known as Rat Alley. It was noted as a site on Warren's Underground Asheville tour and something I'd never seen before. It's located directly under Wall Street and behind some of the shops and restaurants on Patton Avenue. I wasn't quite sure how to access it, but as we walked into a parking lot past Jack of the Wood, I spotted the chain-link fence covering the entrance to Rat Alley. The doorway, propped open by an orange traffic cone, seemed to beckon us inside. We inched into the darkness, glancing over our shoulders and giggling at our willingness to venture into an area we weren't sure if we should enter. Dim overhead lighting cast an eerie shadow over the chaotic assembly of trashcans, mops and empty beer kegs.

We sidestepped a stream of unknown liquid running down the path; some spots, although dry, were very sticky to walk on. A few workers came out of the back door of Jack of the Wood. They didn't seem surprised to find

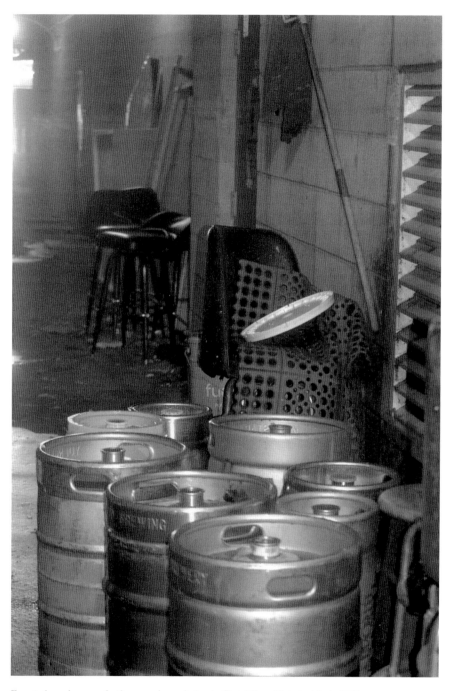

Empty beer kegs and other random clutter in Rat Alley. *Photo by Marla Milling.*

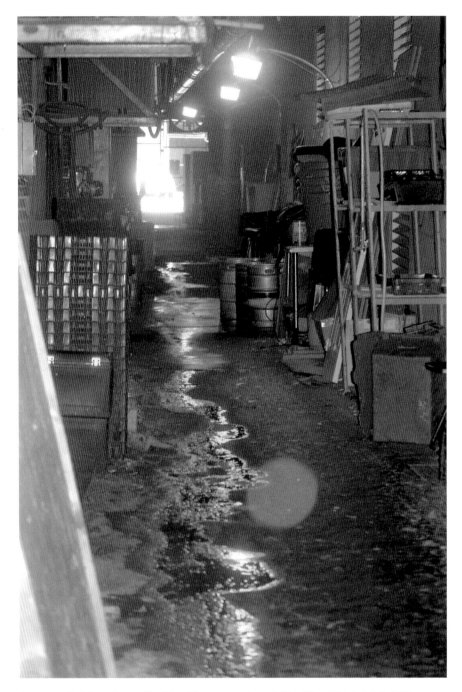

A stream of sticky, unknown liquid snaking its way through Rat Alley. *Photo by Marla Milling.*

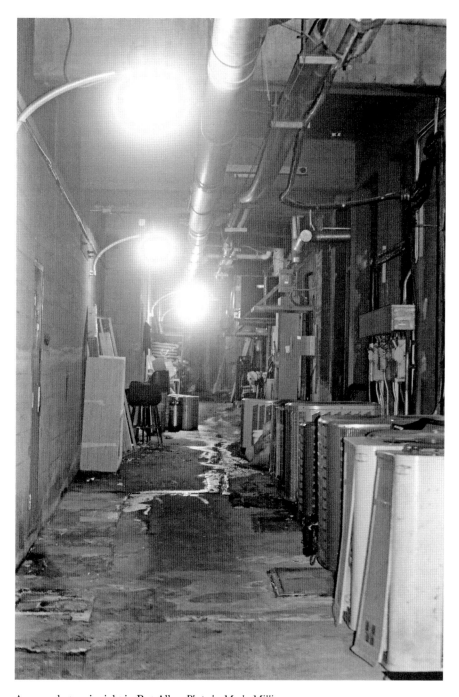
A somewhat eerie sight in Rat Alley. *Photo by Marla Milling.*

us there snapping away with our cameras. Farther down the path, we met Drew, the sous chef at Blue Dream Curry House, as he emerged from the back door of the restaurant. He told us to check out the original cobblestones in this area, apparently from a bygone era when it served as a street. The path ended not too far from the back door of Blue Dream Curry. While I wish I could say it was more exotic in nature, Rat Alley is primarily a dingy storage area. While it does run underneath Wall Street, it's really not an underground tunnel. It is as its name reveals: an alley.

Jackson Underground Café

Another stop was the Jackson Underground Café in the historic Jackson Building, where I stopped with my son for a quick lunch. The Jackson Building is just a stone's throw from Pack's Tavern and also the Vance Monument. Since Pack's has a verified entrance to a tunnel system and Vance Monument once had underground bathrooms, it seems practical to believe that the tunnels might have connected to this building. We descended the steps to the café entrance at the front of the building and went into the cozy but fairly plain space. One wall had been painted black, with the words "Jackson Underground Café" painted in red. Blaine Cone told me he had just bought the business in the summer of 2016 and was still finding out more about the space. He left the corporate world in Atlanta to chase a new career dream in Asheville. When I inquired about tunnels, he said, "Well, there's a basement beneath the café." He offered to go and explore it while we ate, explaining that he wasn't allowed to let guests go down there because it serves as storage for old equipment. After investigating, he told me that the basement area is about the same footprint as the café space. He found one door leading out to a space underneath the sidewalk—he said he could look up and see the grate above—but no tunnel. It's at least fun to have lunch below street level in Asheville and check out the smattering of historic photos of Pack Square on the walls.

Zambra

Warren told a spooky tale that intertwined one of his experiences with the underground tunnels and some unexplained happenings in the old Asheville Hotel building on Haywood Street. Around 1996, he got a call from his friend Mark-Ellis Bennett, who is the historian at the Asheville Masonic Temple and a restoration artist. Bennett told him that he was doing some work in the building and had run into some weird things that Warren needed to see with his own eyes. When Warren arrived, they went under the street level to a big tunnel, where "you could look up and see people walking through the cracks and various openings." He knew Warren was interested in investigating the tunnels, but the main reason he called him over was that he found a few stories above ground. They went up to a room, and Warren spotted the debris. "Smeared on the floor was a pentagram in blood," he said. "Pigeons, squirrels and other little creatures were nailed to the walls. Candle drippings all over the place. It was a very creepy-looking site. It was obvious that some ritualistic stuff had been going on. Mark has infrared film and took a bunch of photos, and with the infrared even more of the gruesome details were apparent."

"It was definitely a creepy place," confirmed Bennett. "There was paint peeling on the wall, a pentagram and a dead pigeon's carcass."

Warren went on to say that when Zambra Restaurant opened on the Walnut Street side of the building, strange things began to get the employees' attention. "Zambra's became the first business to have an exorcism," said Warren.

> *Basically, there was this dark figure that started appearing in the building scaring the hell out of the employees, especially down in the basement. They also had other dangerous things occurring. They would come back in the morning and find out that sometime in the night the ovens had been turned on. People would sit on a certain stool at the bar and get shoved off. It got so bad they hired a shaman, I believe from New York, to do a ritual. A small group of employees gathered downstairs, and they claimed that at some point during the ritual, this dark figure actually materialized. They all saw him. It leapt through the air, head first, into a drift patch of ground. At which point, the exorcist said something like, "This house is clear." It was all hunky dory for a couple of months until activity started up again. They still have some activity, but it's not as much as it used to be. Now, whether the activity had a connection to what I saw, I have no way of knowing.*

Ghosts, Graveyards and Zombies

They like corners. Any spirit will always find a dark corner.
—Santero David Longley

In October 2016, a very unusual invitation went out over social media. Actually, being invited to a séance isn't necessarily abnormal for Asheville, but the rarity came in that the invitation was from Joshua Warren. He and his wife, Lauren, live part of the year in Puerto Rico, and he's in constant demand at conferences, speaking engagements and paranormal investigations all over the world. Luckily, he was back in Asheville when some strange happenings started causing alarm at the new Byrish Haus Restaurant and Pub at 1341 Patton Avenue, the former site of the Barbecue Inn, which was owned by a man named Gus Kooles.

The new owners renovated the space, and that seemed to stir up paranormal activity. They reached out to Warren to see if he could determine what or who was causing the disruption. At the October 19, 2016 public séance, Warren told the crowd gathered there that "it started with objects being literally tossed by some invisible force around the kitchen area. That expanded to people seeing shadowy forms moving around and barstools were knocked over."

Before the séance began, Warren asked if anyone was picking up any impressions of the space. One woman said that she was sensing a man who was lingering outside the women's restroom waiting for someone to come out. She said he was about five foot, ten inches and wearing a light-colored

shirt. A young waitress named Emma Wood was walking through the room at the time she was talking. Emma literally stopped in her tracks and put her hands on the sides of her face. Warren asked her to explain her reaction, and she said she was coming to work one day, and when she got to the door, she looked in and saw a man sitting in the booth across from the women's restroom. She said he was wearing a light-colored shirt and had his fingers laced together with his hands stretched out in front of him—that he was very serious. "I didn't think anything of it," she said. "Then I opened the door and he was gone."

Anticipation was high as people crowded into a room at the far end of the bar for the actual séance. It contained a long table, where Warren sat surrounded by a variety of psychics, sensitives and practiced ghost hunters. Guests took seats at a few random tables, while others staked out spots to stand in open nooks and crannies around the room. Candles flickered and illuminated the dark room as Warren invited the entity to make itself known. Quickly, things began to change—electromagnetic meters registered activity, a pendulum held by a woman at the table began swinging and another woman at the table burst into tears as she experienced an intense feeling of grief. There was other activity as well: some felt touched by something that wasn't there, the temperature in the room suddenly became very cold and then returned to normal and a vibration was felt through the table.

Warren and Shelly Wright, owners of Nevermore Mystical Arts, turned their attention to the glass 3D Ouija board in front of them and lightly placed their fingertips on the planchette. Slowly, the instrument began to move and landed on *O*, followed by *H*. The board then fell silent.

What could be the significance of *O-H*, Warren wondered aloud. His colleague Vance Pollock stunned him with a possibility. He said that O.C. Hamilton built the home that later became the Sky Club.

Putting the Pieces Together

In its day, the Sky Club was *the* place to wine (BYOB) and dine in Asheville. It was owned by a man named Gus Adler and his wife, Emma. Adler initially launched a restaurant in the late '30s called the Old Heidelburg Supper Club, but in 1942, he changed the name to the Sky Club due to the growing anti-German sentiment of World War II. Ten years later, in 1952, Gus tragically died in a fire caused after he fell asleep in bed with a

lit cigarette. Emma continued running the Sky Club and catered meals for many movie productions in Asheville. Stars such as Robert Mitchum, Fess Parker, Susan Haywood and Grace Kelly became regulars at the Sky Club when they were in town filming movies.

Warren theorized that Adler's spirit could be connected with the opening of the Byrish Haus—another German restaurant in Asheville. Another connection may be due to the fact that Gus Kooles operated the Barbecue Inn for years on the site of the new Byrish Haus and may have been friends with Adler. They were both named Gus and both restaurant owners in Asheville when the town was much smaller and at a time when most everyone knew everyone else.

Left: Gus and Emma Adler. *Special Collections, D. Hiden Ramsey Library, University of North Carolina at Asheville.*

Opposite: Emma Adler, owner of the Sky Club, with movie actor Robert Mitchum. *Special Collections, D. Hiden Ramsey Library, University of North Carolina at Asheville.*

Secrets and Mysteries

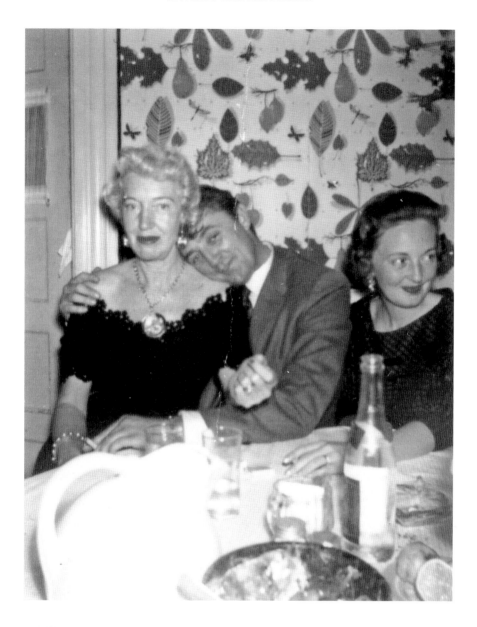

When Pollock mentioned the name of O.C. Hamilton at the séance, Warren had never heard of him, but a great deal of research conducted after the séance has uncovered a big secret. Pollock had been puzzled, and perhaps frustrated, when attempts to find out about O.C. Hamilton led to dead ends. He knew that an Oliver Cromwell Hamilton had bought land on Beaucatcher Mountain from E.T. Clemmons and built the home that

later became the Sky Club. He and his wife, Kate, moved to Asheville from Chicago around 1895 and had a daughter named Mary Amalgad Evelyn Hamilton. Hamilton was born in 1856 and died in July 1916.

Pollock's tenacity in connecting the dots led to Buncombe County deeds that show that a John Joseph Carroll purchased land on Beaucatcher Mountain from E.T. Clemmons in 1896. The name of Carroll's mother was Mary Amalgad Carroll. Carroll was also born in 1856 and died in July 1916.

Warren said that Carroll, a Roman Catholic priest, assumed a new identity and moved with his pregnant lover, Kate, from Chicago to Asheville, somehow managing to keep the secret from coming out. Until now. "I said at the séance that we were going to cast a wide net," said Warren. "I believe Gus Adler's spirit is here. I also believe O.C. Hamilton's spirit has a lot of weight on his shoulders. If this man believed in purgatory, then maybe he created that for himself." He continued by saying that perhaps Hamilton's spirit needs forgiveness and help into getting to a better place.

Blessing the Space

On October 28, 2016, Warren returned to the Byrish Haus to reveal findings about Carroll's double life as O.C. Hamilton. He also invited those gathered to participate in a blessing that would hopefully clear the building of any lingering spirits. In the back meeting room, three people were sitting at the long table: Lady Passion and *Diuvei of the Coven Oldenwilde and Santero David Longley of Puerto Rico. A "santero" is a priest of the Santeria faith and someone skilled at cleansing spirits.

Lady Passion became very agitated as people were entering the room and warned that an entity was sitting in the corner. When unknowing guests would enter and sit in that area, she would wring her hands and start muttering and sometimes put her head on the table if they failed to listen to her disjointed communication. She then began speaking a different language, or a chant or perhaps a spell, while *Diuvei lit some frankincense resin. Wands created by the santero were passed among the crowd with some specifications—a certain wand to someone with such attributes as bird qualities or water qualities or earth qualities.

As the witches worked to clear the room of the entity, Lady Passion suddenly said that it was time to go to the only other haunted area she had encountered: the outside of the women's restroom. She paraded the crowd through the bar

Secrets and Mysteries

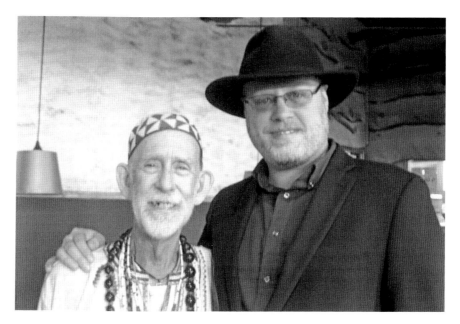

Santero David Longley (*left*) and paranormal investigator Joshua P. Warren at the Byrish Haus Restaurant & Pub in Asheville. *Photo by Marla Milling.*

and into the main dining room at the surprise and amusement of people eating their evening meal. She crowded the group in a corner outside the restroom and worked with chants and spells to banish whatever was there and then had everyone return to the room behind the bar.

The seventy-two-year-old santero began his portion of the ceremony by answering questions. He said that he has been a santero for fifteen years and had to work hard to prove his sincerity to be accepted into the religion because he is white. He said that when he entered the Byrish Haus, he sensed coldness by the ladies' bathroom and by the bar, and he noted that he felt the entity was especially upset in the kitchen, perhaps because they were no longer preparing barbecue. He said he would recommend taking a plate of leftovers every night and offering it to the entities.

The santero then began his cleansing ritual. He first blessed and cleansed everyone in the room by encircling their necks with a hair talisman. The silky feel of hair on skin created a soothing, peaceful feeling. After he touched everyone in the room, he went through and cleansed the building, both inside and outside.

Will the strange activity cease at this point? It's anyone's guess. Emma Wood said that she feels like the energy of the séance pushed out whatever was there. The owners have put up a new addition since the séance. In the

hall across from the men's bathroom is a framed announcement that notes that the building is haunted, along with details of Gus Adler and his picture.

The Pink Lady

In 1996, the Grove Park Inn hired Warren to formally investigate the stories of the "Pink Lady." That's the name given to the resident ghost. It's believed that the inn is haunted by the spirit of a young woman who fell to her death from the fifth-floor balcony of the Palm Court at Grove Park Inn in the 1920s. She was dubbed the "Pink Lady" for her appearance. Some have said it's a pink mist; others claim to see her wearing a pink ball gown. Warren detailed his research in his book, *Haunted Asheville*. He focused much of his investigation on room 545. I won't detail his discoveries here, as his book is a worthy read on its own, but he did write, "By the end of the investigation, however, I would come to consider 545 the most haunted room in the Grove Park Inn."

A few years ago, I booked a night's stay at the Grove Park Inn with my kids and asked for room 545. I hoped for a ghostly encounter when we made ourselves acquainted with the room, but it was quiet and initially revealed nothing out of the ordinary. I guess it's like the proverbial "watched pot never boils," as my invitation to the Pink Lady to show herself was unproductive—at least I thought so. The windows of the room face the parking lot. I pulled back the curtains at one point to make sure that the windows were locked. They all appeared secure, and we settled down for a night's sleep. The next morning, I heard voices talking—much too loudly, I thought. The voices were coming from the ground-floor entrance, and we were just overhead. I pulled back the curtains to peer outside, and the window I had checked the night before was fully extended and secured in an open position. Could the window have slid out of its lock and opened somehow? I guess anything is possible.

The Battle Mansion

Unexplained happenings also occurred at the old Battle Mansion, which once stood beside the Grove Park Inn. (Today, the high-dollar Fitzgerald Condos—a collection of twenty-four two- and three-bedroom residences—adorns the

property.) Originally the home of Dr. S. Westray Battle, the Battle Mansion later served as studios for WLOS-TV, where I worked from 1988 to 1998. The old mansion had many nooks and crannies, creaks and bumping sounds at night. For six years, I arrived at the building at 4:30 a.m. to produce the morning and noon newscasts. I would turn off the alarm and make my way through a darkened front lobby to flip on the lights in the newsroom. During the time of my work, there was only one other employee in the building: an overnight engineer, and most often that was Chris Walker.

There were plenty of tales of a ghost named Alice, a chambermaid who reportedly died after falling down a staircase. During one stretch of time, a cleaning crew would be in the building when I arrived at 4:30 a.m. I always felt relieved knowing that other people were in the building. They would clean the newsroom before I arrived and then move to the second floor. I became accustomed to their patterns and hearing the creaking floor above me as they vacuumed and bumped around cleaning. One morning, I was sitting at my desk in the newsroom and heard the familiar bumps and rustling overhead. Then it dawned on me: the parking lot was empty when I arrived. Where was the cleaning crew's van? I called Chris, and he told me they had to change their schedule and had left hours before I arrived. "Someone is upstairs, though, I hear them," I told him on the phone while still listening to a continuous stream of bumps and thumps. Chris surveyed the entire second floor and came down to report that no one was there; the building was secure, and he didn't know what I could have heard. To me, it sounded like the cleaning crew's normal vacuuming, walking and thumping around, and it had continued for quite some time. Alice? I'll admit that going into a darkened mansion night after night definitely kept my guard raised, and not all of the happenings were of an unexplained nature—sometimes it was co-workers trying to scare the others, like the time someone pushed a cardboard cut-out of actress Judith Light to stand at an upper-floor window. More than one employee coming to work at night got a few chills when they spotted the figure looking out the window, but again, that was just a joke.

The strangest events would occur when Chris would respond to a door alarm in the building. Usually, it was a third-floor door that would pop open mysteriously in the night. He would walk through the newsroom clutching a flashlight and jokingly tell me to call 911 if he didn't return.

I reconnected with Chris to get his recollections. He said:

> *Weird stuff happened all the time on that third floor. Part of our commercial library was stored up there, so I got to make a trip up nearly every night.*

> *There were two doors that would "pop" open. One went out to the third-floor deck; the other to a fire escape. The fire escape door was wired to the alarm and had a heavy deadbolt lock on it. That very lock was the one I would check early in the night only to have the door pop open and set off the alarm anyway. The door to the deck would pop open also. It was open almost every night. Supposedly, Alice liked to hang out on the deck. Other strange stuff would happen up there, too. The motion detector alarm and the fire alarm would go off for no reason. Light switches would work one night and not work at all the next night. The light in the old radio studio would turn on and off even though the door was always locked. Weird stuff would happen on the second floor, too. The floor would creak like someone was walking around. I've heard different stories about the haunting of that house. One claims there are two ghosts: Alice and Dr. Battle.*

Gary Stephenson had a strange experience while working as a weatherman for WLOS. He spent thirteen years working in the Battle Mansion from 1989 to 2002. He's now the chief meteorologist at *Time Warner Cable News* in Raleigh, North Carolina. One Saturday evening in the early '90s, when he was working to prepare the forecast for the 11:00 p.m. newscast at WLOS, he stepped into the restroom to wash his hands around 10:00 p.m.

> *I heard the sound of someone walking down the hall outside of the restroom leading to the studio. It was quite the commotion, but I didn't think much about it. I assumed that members of the production crew were getting an early start for the upcoming newscast. I walked back into the studio to find it empty. No one from the production crew was there. I thought, "Maybe someone came down and went back into the newsroom through the back of the building." That would have been unusual since the route through the back of the building at night was a little spooky, but I thought nothing more of it. Around 10:30 p.m., a camera operator walked into the studio. I asked why he came down thirty minutes earlier and left. He told me that no one from the newsroom had come anywhere near the studio since the early evening newscast and that he was the first person down prepping for the late news. I looked at him and said, "I guess Alice is wandering the halls tonight."*

REYNOLDS MANSION BED & BREAKFAST INN

I initially went to the Reynolds Mountain Bed & Breakfast Inn to talk with co-owner Billy Sanders about the legacy of the Reynolds family and its tie to the famous Hope Diamond. I discovered while talking to Billy that his inn has its share of ghost stories—much of the activity includes strange noises, doors opening and closing without explanation, shadows on the wall and even the appearance of apparitions in photos.

"The first people to ever do a paranormal investigation on it was *Ghost Hunters* on the Syfy channel. Those people are kind of hokey. They love to do that kind of stuff at night, but you know if a house is haunted it's haunted all the time—not just at a certain time of day," said Sanders. "I've learned over the years that you have to have the ability to be able to see that. I do not, but I've seen the effects of it. What I think it is—it's almost like static electricity. I think it's energy that's just built up over time, and when the conditions are right that fires off and people see that very, very differently."

Sanders and his partner, Michael Griffith, bought the declining home in 2009 and spent a year and a half restoring it to its original grandeur from

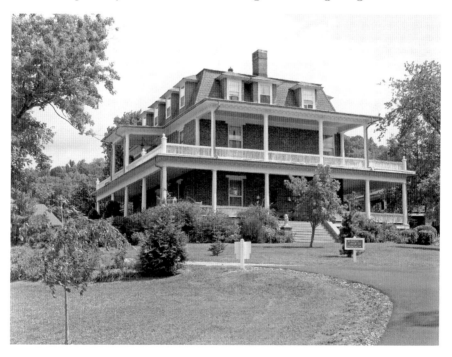

Side view of the Reynolds Mansion Bed & Breakfast Inn. *Billy Sanders, co-owner of the inn.*

the days when Daniel and Susan Reynolds lived in the home and raised their ten kids—five girls and five boys. One of the girls, Anne Lee, never married and lived out her days in the house. Her former room is on the third floor and is now called "Maggie's Room." Sanders said that one of the oddest stories since they began running the inn took place in this room. A couple checked in and put their bags in the room. When they returned from an outing, they told Sanders they couldn't get into the room. He told them it was the skeleton key, but they said, "No, it's not that. Something is barring the door." So Billy took the skeleton key up to open it for them. "She was right. You could open the door, but just a little bit," said Sanders. "There was a closet at the end of the hall. You pull the floor out and you can go underneath and into the closet of that room, so that's what we had to do. Every bit of their luggage was stacked behind the door. I honestly believe it was because of them. She did not like them staying there."

Sanders also related an experience involving the first-floor bedroom:

> *When Joshua Warren did his paranormal investigation here, he brought a spiritualist. I was in the kitchen, and she came in and said, "There's a young girl in this room who is saying she was embalmed here." I didn't say anything to her. I've learned the less you say, the more you can validate things. I knew Joseph Morris, Nathaniel Reynolds's great-great-great-great-grandson—he's passed away now—he told me that his great-great-grandfather used to own the funeral home on Woodfin Street, which is now Morris Funeral Home. I told him about what the woman said about a girl being embalmed here. I asked if he knew of that ever being done on Reynolds Mansion property, he said, "Oh hell, they used to embalm them out there in the old garage." It's amazing what you find out as time progresses.*

HELEN'S BRIDGE

Joshua Warren also had a creepy experience at one of Asheville's most famous haunts, Helen's Bridge. According to legend, a grief-stricken woman named Helen hanged herself from the bridge atop Beaucatcher Mountain after her daughter died in a fire. Warren was driving home from a friend's house the night before Halloween 1996 when he decided to test the tale, which said that a ghostly apparition would appear if you called, "Helen come forth" three times. He rolled down the window of

his Chevy Lumina and began the triplicate chant: "Helen come forth." "Instantly the alternator died on my car," said Warren. "I didn't have a cellphone back then, and I had to roll my car off to the overgrown shoulder of the road. I'll never forget heading, on foot, all the way down that silent mountain, the fog seething around me, to the nearest payphone on Tunnel Road. As I walked from under the bridge, clear, human footsteps suddenly crackled in the dry leaves behind me, following me at a steady pace. I had long decided my research that night was done, and I high-tailed it down the mountain without ever looking back!"

Riverside Cemetery

A tombstone in Asheville's Riverside Cemetery, located in the historic Montford neighborhood, is often strewn with pennies and other assorted coins. The goal, of course, is to leave $1.87—the amount detailed in O. Henry's short story "The Gift of the Magi"—although there's often a differing amount, as more visitors toss their own onto the slab. In the story's ironic twist, which was a trademark of O. Henry's stories, a wife sells her beautiful hair to buy her husband a watch chain, and he sells his beloved watch to buy her hair combs.

O. Henry was the pen name of William Sydney Porter, a Greensboro native who lived for a time in Asheville. He is buried beside his second wife, Sara Coleman Porter, who was a Weaverville native. His full name is emblazoned on the tombstone, followed by "1862–1910," but it's the chaotic assortment of coins that makes it so unusual and charming. The spare change is gathered up periodically by Riverside Cemetery staff and donated to local library funds in honor of O. Henry.

O. Henry's grave is just a short walk (or drive) from the grave of famed novelist and Asheville native Thomas Wolfe, and guests also leave an assortment of items at his grave. A small urn in front of his grave now contains a random assortment of pens, pencils and notes. When I tweeted a picture of the writing implements in September 2015, officials from Riverside Cemetery tweeted back to me saying, "The pens have been showing up for 2 years now, often with messages for Thomas Wolfe attached." Wolfe might well have found this pleasantly odd and reflective of his hometown and residents that he immortalized in his 1929 novel, *Look Homeward, Angel*. His standing tombstone is much wordier than O.

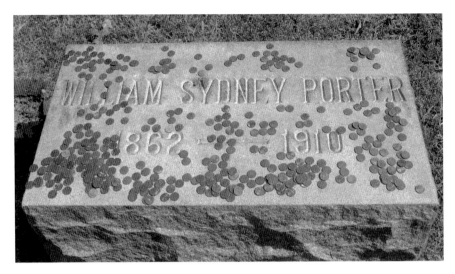

Pennies strewn on the headstone of William Sydney Porter's grave at Asheville's Riverside Cemetery. Porter wrote under the pen name O. Henry. *Photo by Marla Milling.*

Henry's—fitting since O. Henry was master of the short story and Wolfe wrote impossibly lengthy novels. The tombstone has a big "TOM" at the top, followed by these words: "Son of W.O. And Julia E. Wolfe, A Beloved American Author, October 3, 1900–Sept. 15, 1938, 'The Last Voyage, The Longest, The Best,' Look Homeward Angel. 'Death bent to touch his chosen son with mercy, love and pity and put the seal of honor on him when he died.' The Web and the Rock."

Riverside Cemetery sits on eighty-seven acres of rolling hillside. It's serenely quiet, with those who lived before whispering, "We were once where you are, you will one day be where we are." David Voyles, owner of Dark Ride Tours, frequently takes guests into Riverside Cemetery—his son drives them in a hearse—and he tells an assortment of fictional tales interspersed with some real-life nuggets, such as Asheville mass murderer Will Harris being buried in an unmarked grave in an area known as Killer's Hill. He admits being skeptical about ghostly happenings in the cemetery, but one encounter with a newly married couple has kept him wondering. The man first took his tour in October 2015, and while David was telling a story near the Rumbough Crypt, the man wandered off. When he returned, he explained that he had seen a couple of young men peer around a tombstone and then disappear. He told Voyles he is sensitive to spirits and that while he didn't normally see ghosts in a cemetery, he felt that Riverside was extremely active.

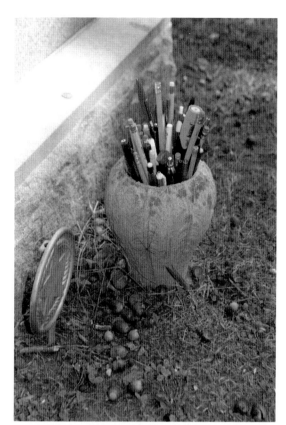

Right: Closer view of the writing implements left at the grave of Asheville author Thomas Wolfe. *Photo by Marla Milling.*

Below: Author Thomas Wolfe's tombstone in Riverside Cemetery features an urn in which visitors leave a random assortment of pens, pencils and notes. *Photo by Marla Milling.*

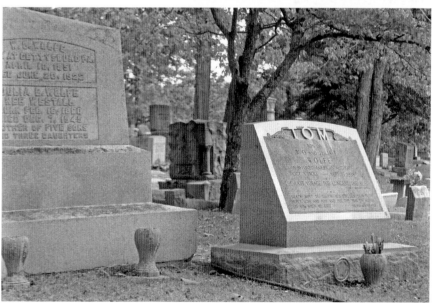

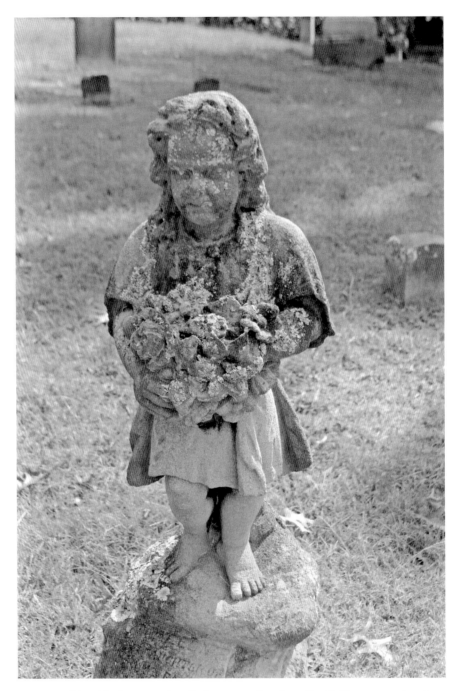

A statue at Riverside Cemetery that displays years of neglect. Could this grave marker show the wrong name? *Photo by Marla Milling.*

Secrets and Mysteries

In September 2016, the man returned with his new bride (also a psychic) and booked a private outing with Dark Ride Tours. Once again, near the Rumbough Crypt, the man said he was seeing some male ghosts that were really irritated. "They don't think we're supposed to be here," he told Voyles. "This was their land, and they don't think we belong here." As they walked on, they came upon a towering monument featuring a beautiful ornate angel. "There is a little girl statue on the right," said Voyles. "The woman said, 'Wow, this little girl is pissed.'" He said the woman then pulled a pendulum out of her pocket and dangled it over her left palm. She did this, he said, to get a reading on things she was seeing and would then stand for a while with her eyes closed, arms to her side, with palms turned outward. As she was helping to ease the spirit's discontent, the husband came back and said, "I hope I'm wrong, but I believe there's a demon there." He pointed to a row of big oak trees near a crypt with ivy growing over it. Voyles said the man walked over to the trees and stood with eyes closed, palms turned outward, for several minutes. He returned holding his stomach and said, "Wow, that really hurt, but I think I took care of it."

Voyles identified the woman as owner of a Charlotte business called Tarot with a Twist, which includes readings, guided meditations, classes, energy work and more. Her name is Karen Yoder, and I reached out to her by phone to find out more about her experience at Riverside Cemetery. "The most striking one was a little girl who was still attached to the monument of her, but it was the wrong person," Yoder said. "She was like, 'This is not me. It's not my grave.' The name on the marker was not the name of the little girl buried there. She was furious a mistake was made and no one ever discovered it. We helped her let go so she could start her journey on the other side."

Yoder said that they began feeling the energy upon arrival:

> *As soon as we got in there, we said, "Oh, we've got work to do." It's not that spirits are attached to every grave. There are a lot of people who pass on who cross pretty quickly. When you do encounter energy in a cemetery there's always a reason. Either an error has been made or they don't understand they are dead and don't know where to go. Everyone is different. Some are afraid to cross because of the old fire and brimstone judgment. Sometimes you have spirits that keep other spirits from passing. There are hundreds of reasons why spirits choose to stay or get stuck. I'm sure there's more energy there. I am sure someone else can do a lot more.*

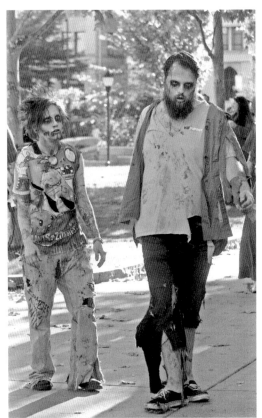

Left: A couple of zombies wander through Asheville's Pack Square Park during ZombieWalk 2015. *Photo by Marla Milling.*

Below: A trio of zombies comes to life in Aston Park in Asheville for ZombieWalk 2016. *Photo by Marla Milling.*

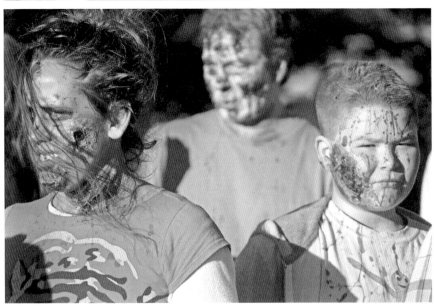

ZombieWalk

Every October, Asheville's streets resemble a scene from the TV show *The Walking Dead*, as young and old put on their most gruesome costumes and gather for the annual ZombieWalk. The eleventh-anniversary event took place on October 9, 2016, at Aston Park. "It's a little different every year," said Jim MacKenzie, who runs Asheville ZombieWalk with his college friend Sarah Giavedoni. "It's not the same event from year to year, which is maybe one of its strengths and one of its weaknesses." Jimmy and Sarah have been to every ZombieWalk, but they started as volunteers and eventually took over running it when the founder stepped away. They had always been interested in monster movies, horror, vampires and ghouls, so running this unique Asheville event is a perfect fit for them and runs parallel to their blog StuffMonstersLike.com, which they've been updating for almost nine years.

"The whole idea of how this ZombieWalk started and why it continues is that it's October—leaf season. There are a lot of people coming in from out of town. They might not understand what's going on. In the distance, they hear this moan and it's coming closer," said MacKenzie. "As they see the zombie horror approaching, you can see it in their eyes. They are wondering, "What is going on?" "Do we need to run?" They're sitting there having dinner with family and suddenly downtown is swamped with zombies. The looks on people's faces totally makes the six months we spend planning it totally worth it."

The Search for Amelia and Other Aeronautical Feats

Women, like men, should try to do the impossible. And when they fail, their failure should be a challenge to others.
—Amelia Earhart

It's been eighty years since Amelia Earhart set out to become the first woman to fly around the world. She announced her plan on February 12, 1937, and took off on March 17, 1937. A mishap days later forced plane repairs and time for regrouping. She began her second attempt on May 20, deciding this time to travel east. She successfully landed her plane—the *Electra*—in New Guinea on June 29. The next leg of the trip has baffled aviation experts and historians for decades. She never made it to her destination of Howland Island after radioing that she was low on fuel. Despite frantic searches by the U.S. Coast Guard and U.S. Navy, Earhart and her navigator, Fred Noonan, were never found.

Some theories claim that she landed on the water and sank without a trace, while others suggest that they were captured by the Japanese. Ric Gillespie doesn't believe either of these things happened. He's the executive director of The International Group for Historic Aircraft Recovery (TIGHAR), and he's been investigating Earhart's disappearance for twenty-eight years. He believes that Earhart and Noonan made an emergency island on Gardner Island, also known as Nikumaroro, a small coral atoll that's four and a half miles long and a mile and a half wide in the western Pacific Ocean. He's headed back to that island this year, 2017, and joining him will be Asheville climate scientist

Dr. DeWayne Cecil of The Collider, with offices located in the Wells Fargo building across from Pritchard Park.

In a video Gillespie posted to YouTube on August 11, 2016, from a presentation he gave at The Collider titled "Finding Amelia with Hard Facts and Sound Science," research points to Earhart and Noonan living out their days as castaways despite repeated SOS calls and attempts by Earhart to get help for herself and her badly injured navigator. He says of the 120 reported radio distress calls believed to be from Earhart from July 2 to July 7, at least 57 are credible; 47 of those messages were heard by professional radio operators, but others were documented from people in the United States while listening to short-wave radio. One of those listeners was teenager Betty Clank in St. Petersburg, Florida. When she heard someone say, "This is Amelia Earhart" as she was tuning her radio, she grabbed a notebook and began jotting down what she heard over the next hour and forty-five minutes.

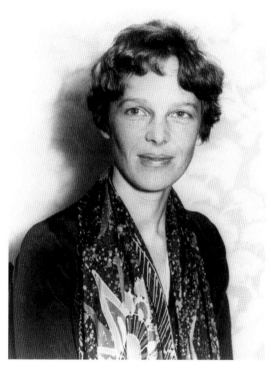

Aviator Amelia Earhart. *Library of Congress Prints and Photographs Division, Washington, D.C., 20540 USA.*

Dr. Cecil had been following TIGHAR's research on Amelia Earhart for about six years. In December 2015, he felt that it was time to introduce himself and offer his expertise. He's built an incredible career. He spent the first thirty-one years of his career in the federal sector working for all three of the space agencies of the U.S. government—NASA, NOAA and the U.S. Geological Survey. In his last year as a federal employee, he served as the western region climate services director for NOAA, which was assigned to the National Climatic Data Center in Asheville. He's been in Asheville for a little more than five years, currently serving as chief climatologist and

program director for global science and technology. He also founded his own company in the summer of 2015 called Sustainable Earth Observation Services, where he does aerospace applications and climate services. Both companies operate out of The Collider. "We see The Collider as a real opportunity for private sector, academic sector and government sector to all work together on climate solutions, and I see it also as a think tank in Western North Carolina for all kinds of things—adventure, exploration, science and science applications. It's just a melting pot of scientists and engineers and explorers. A very important aspect of The Collider is capacity building, training, inspiring and exciting the next generation of scientists and engineers and explorers and managers," he said.

He called Ric Gillespie in December 2015, and Gillespie headed to Asheville, where they quickly recognized the benefit of teaming up. I stopped by Dr. Cecil's office at The Collider on the first day of the fall of 2016 to ask him about his responsibilities when he sets sail with TIGHAR from Honolulu in the summer of 2017. Nine days will pass before they arrive at Nikumaroro; ultimately they'll be at sea for a month, timing their expedition so they'll be there during the eightieth anniversary of her disappearance on July 2. "I've got a couple of roles," he said. "What I'm going to do is hindcast using computer models. I'm going to hindcast and determine a range of what the weather conditions may have been on the day she disappeared and see if we can perhaps map out some of the potential flight paths she may have been on due to upper air winds and changes in the weather. We'll see if we can reconstruct some of the places where she may have flown off course." He'll be aided with deck logs that TIGHAR has compiled from U.S. military ships that were in the vicinity. He's also going to attempt to get the logs of weather observations from two other ships that were in the area at the time—a New Zealand freighter and a British naval ship.

> *Another thing I'm going to do—it's not just an exploration expedition, it's also science—I will be on one of the two submersibles as an observer. I'll be looking at the condition of the deep-sea corals off Nikumaroro and changes in the fish population. We're going with researchers from Boston University and New England Aquarium to look at the condition of the corals and what changes and impacts we can see from climate change. The area is currently in the largest marine protected area in the world. And there's a third thing I'm putting together. We're working with the Nesbitt STEM High School in Asheville and other schools in WNC to put together a STEM history experiment. Students will partake in the expedition in a*

virtual sense. We'll broadcast in real time back here to The Collider, and we'll have the students do their own research and come up with their own conclusion of what they think may have happened and make their decisions on whether they think we're looking in the right place. Plus, we'll have them look at the choices Amelia Earhart made throughout her life. She wouldn't let anybody tell her no—that might influence them as they go forward in their science and engineering and management and/or exploration careers.

Dr. Cecil finds it very exciting to be helping in the hunt for Earhart's plane. Fascinated with aviation since he was a young boy, he pored over books in his youth, focusing on Earhart, Charles Lindbergh, the Wright brothers and even some French pioneer aviators. "If we find some Lockheed *Electra* debris, then that will put a final chapter on her courageous life and her flying career," he said. "We all hope we can find some debris from the aircraft. Some of us feel pretty strongly that we'll find something, but then again, it's been eighty years and it's deep water. These submersibles can work down to six thousand feet in depth, but we're hoping we can find some debris on the deeper banks of the coral reef before we get down to that depth. If we don't find the debris, then perhaps we'll give somebody inspiration to look somewhere else."

Note: During the production of this book, reports in a variety of news outlets in November 2016 revealed new evidence to show that a skeleton found on the island of Nikumaroro may well belong to Earhart. TIGHAR has been trying since 1998 to prove that the bones were Earhart's. Contemporary forensic methods reportedly revealed bone measurements consistent with Earhart's arms as researched from historical photographs. While that's not proof that the bones were hers, it does make it easier for researchers to believe that Earhart lived out her days as a castaway. The investigation is ongoing.

UNBELIEVABLE FEAT

Asheville native Robert Morgan made aviation history in World War II as the pilot of the *Memphis Belle* B-17 Bomber. He and his crew completed twenty-five successful combat missions over Nazi-occupied France and Germany. He returned home a true war hero, but it's an incident on August 11, 1943, that created quite a stir in Asheville. Thousands saw the amazing, almost impossible sight as Morgan roared over the Vance Monument and tilted his

Above: The crew of the *Memphis Belle*, including Asheville pilot Robert Morgan. *North Carolina Collection, Pack Memorial Library, Asheville, North Carolina.*

Left: Marker between the Buncombe County Courthouse and Asheville City Hall, which memorializes Robert Morgan's daredevil stunt of flying his *Memphis Belle* bomber between the two buildings. *Photo by Marla Milling.*

plane in an incredible stunt to allow passage between the Buncombe County Courthouse and Asheville City Hall.

Even though there were many witnesses, the story met with speculation over the years. A plane passing between the two buildings? How was that possible? In an *Asheville Citizen* article on October 7, 1990, Morgan finally talked about his daredevil escapade. "I remember that day in more ways than one," he said. "I nearly tore the airplane up landing at Asheville. I nearly ran out of runway and ran into a ditch, which would have been a catastrophe. And I remember buzzing the city and going between the courthouse and city hall." He told the paper that he made the pass sideways with wingtips facing the sky and the ground, and then he said, "We pulled up at [Beaucatcher] mountain."

Situated between the county courthouse and city hall is a monument, installed in August 2014, that commemorates the legendary flight. The granite monument features an etching of a painting of Morgan's bomber flying between the buildings. It was placed ten years after Morgan's death.

The Best and Bravest of All

If you drive down Merrimon Avenue in north Asheville, you'll pass a state historical marker honoring the late Kiffin Yates Rockwell. Located across from Claxton Elementary School, the marker reads, "Kiffin Y. Rockwell, World War I soldier, aviator, first pilot of Escadrille Lafayette to shoot down enemy plane. Killed in action Sept. 23, 1916. Home 200 yds. W." I suspect many people see the marker and never think about it or question who Rockwell was, but he was one of only four North Carolinians who flew for the French Service Aeronautique during the First World War. He and his brother were quick to act when Germany declared war on France on August 3, 1914. They immediately wrote to the French consul in New Orleans offering their services and left days later before receiving a reply. They set sail from New York on August 7. A day before, Kiffin sent his mother a letter saying, "We would have gone by home to see you and explain things if there had been time. But we had to do some hurrying to catch this boat....I don't want you to worry or feel bad. You have always told me that you wanted me to live my life without interference and this opportunity is one that only comes once in a lifetime. I would not have come with Paul if I had not felt it was really a great opportunity."

On May 18, 1916, Kiffin became the first American aviator to shoot down a German plane. It was his very first combat mission and the first time he had encountered an enemy plane in the air, as well as the first time he had fired his gun at a German plane. He detailed the successful operation in a letter to his brother, Paul: "Just as I was afraid of running into him, I fired four shots and swerved my machine to the right to avoid having a collision. I saw the gunner fall back dead on the pilot, his machine gun fall from its position and point straight up in the air, and the pilot fall to one side of the machine as if he, too, were done for. The machine fell off to one side, then dove vertically toward the ground with a lot of smoke coming from the rear." He was awarded the Medaille Militaire and the Croix de Guerre.

His mother, Loula Rockwell, wanted her boys home. She lobbied the French and American governments to send them home, but Kiffin wrote to her saying, "If I die, I want you to know that I have died as every man ought to die—fighting for what is right. I do not feel that I am fighting for France alone, but for the cause of all humanity—the greatest of all causes."

Kiffin Rockwell entered his 142nd dogfight on September 23, 1916. In a battle with a German plane, he suffered a shot to the chest, killing him instantly. His plane reportedly crashed in a field of flowers less than two and a half miles from where his first air victory sent a German plane down. He received full military honors at his burial at Luxeuil-les-Bains, France, on September 25, 1916. He was deeply mourned by his comrades, who considered him not only a top-notch pilot but also someone who was well liked and widely respected. The French commander of the Escadrille Lafayette said, "When Rockwell was in the air, no German passed…and he was in the air most of the time. The best and bravest of all is no more."

The state historical marker honoring Rockwell was installed in Asheville during a ceremony in May 1954.

PART II
HIDDEN TREASURES

Time Capsules

The fact that every last piece was salvageable is unheard of—it's really kind of crazy.
–Archivist Heather South

The thought of opening a time capsule creates a great deal of excitement, anticipation and ultimately surprise, as a current generation takes a peek at things hidden for decades. In 2015, Asheville had the opportunity to release a time capsule from its tomb and investigate whether its contents had endured. City officials made the decision to remove the time capsule located in the base of the Vance Monument because they feared that restoration efforts could damage or destroy the box of goodies the Masons had planted there in 1897.

Named after Zebulon Vance, a Civil War–era governor, the monument on Pack Square is one of Asheville's most iconic landmarks. An assessment of the obelisk in 2008 revealed that it was suffering from corrosion, failing mortar joints, corroded markers and stain. As reported by the *Asheville Citizen-Times*, "In 2012, the nonprofit 26th North Carolina Regiment took up the cause of raising money for repairs….The nonprofit is named for the Civil War regiment Vance commanded." The city council accepted $115,000 from the group in March 2015 to repair the monument, and the city added $11,000. Officials decided to remove the long-forgotten time capsule just before launching the repair work, which included cleaning and repairing mortar joints and repairing the wrought-iron fence.

"For the most part the community in general had lost track of the fact that there was a time capsule there because there was so little record of it," said

Debbie Ivester, assistant director of the Parks and Recreation Department for the City of Asheville. "Well, the Masons knew it and they had records of the original one, so they pointed us in the direction to say there is a time capsule and here's what we know about it. The day after it was installed, there was an article in the [*Asheville Citizen*] that actually listed what was in the time capsule. That's the only record we had, and sure enough, everything on that list was actually in it. It was commissioned in 1896 and installed in December 1897. If we had not being doing the work on the monument, we would not have just randomly taken out that time capsule."

On a very cold morning in March 2015, workers began the process of removing the time capsule. State archivists stood by to quickly remove the contents, get them into a box and take back to their lab to examine in a climate-controlled environment. "It took a lot longer to get out than envisioned," Ivester continued. "I thought the box would just slide right out of there, but it didn't. It had gotten embedded because over the years as the structure settled and shifted, it had compressed the box."

Program from the Vance Monument Time Capsule Ceremony in 1897. *Western Regional Archives Department of Natural & Cultural Resources, Asheville, North Carolina.*

Vol. 5, No. 23. ASHEVILLE, N. C. July 17, 1897. Price 5 cents Copy

The Kindergarten Fair.

Pretty girls, pretty booths, pretty wares and a pretty good crowd of visitors—that was the condition of the Kindergarten Fair at its opening, Thursday night.

The ladies whose energy made it a success should be proud of their efforts. The different booths and their guardian angels were as follows:

Fancy Work Booth, Mrs. Collins, assisted by Mrs. C. K. Evans, Miss Nellie Rogers, Miss Willie Schartle and Mrs. L. A. Farinholt.

Exhibit of Kindergarten work, Miss Clegg.

The Post office—Mr. H. W. Fain, assisted by Miss Flora Fain, Miss Wessie Clark, Miss Nina Deaver, Miss Eva McCandless and Miss Nellie Lindsey.

The Mystic Maze—Miss Jean Brody.

Silhouette Tent—Mr. Fred Hull, assisted by the Misses Morse and Miss Blanche Atkinson.

Fortune Teller's Tent—Mrs. M. Schirrmeister, assisted by Miss Florence Manheim.

Lemonade Stand—Miss Maud McCrary, Miss Hansen, Miss Robertson and Miss Barnard.

Candy Booth—Mrs. F. R. Darby, assisted by Miss Edith Corse and Miss Bishop.

Restaurant—Miss Robb, assisted by Misses Nora Ware, Kathleen Ware, Daisy McLoud, Clemmie Buckner, Della Miller, Linda Schartle, Lulu Lindsay, Alice Stockton, Flora Fain. Miss Frances Gudger, cashier.

Mrs. Atkinson, Mrs. Starnes, Mrs. Shuford and Mrs. Fain attended to the preparation of the refreshments.

The Dog show on Friday was the most howling success of the entire fair.

A neat sum of money was raised for pushing the free Kindergarten work in Asheville.

A Handsome Paper.

A handsome paper comes to us in the form of the trade edition of the Hendersonville Times. We congratulate Hendersonville on her enterprise.

To the Epworth League Convention, Toronto, Canada.

Those who went from Asheville were: Geo. L. Hackney, J. A. Nichols, Miss Mary Nichols, Rev. Geo. F. Kirby, Miss Annie West and Miss Carrie Nichols.

Public School Election, August 10.

By act of the General Assembly an election will be held in every township in North Carolina in which there is no local taxation for school purposes, Tuesday, August 10, for the purpose of improving the Public Schools by local taxation.

The State of North Carolina has appropriated $50,000 out of the General Fund to be appropriated among the townships voting in favor of local taxation. If a township votes a tax of 10 cents on the $100 worth of property and 30 cents on the poll and thus raises $500 in addition to the usual school fund, the State will add $500 more, making the extra amount added to the School Fund in the township $1,000. If the township raises $300, the State will give $300. If it raises over $500 the State will add $500.

Any township that votes for local taxation will, therefore, be sure to have first class public schools.

Col. J. S. Carr has promised to give $500 to the school fund of the county that votes the largest per cent of its voters for local taxation. Let all strive to get this bounty.

Remember the day, August 10. Be at the voting place and bring your neighbors. To stay away will be equal to voting against this plan to get good schools for only a small expense. The tax of ten cents on the $100 is only one dollar on the thousand or five dollars on the five thousand. Surely every citizen will see that thus the best schools can be obtained cheaper than any other way.

Those desiring literature for information or to distribute, send to J. W. Bailey, Chairman, Raleigh, N. C.

ABOUT TOWN.

Mr. R. S. Morgan has sold his interest in the firm of Morgan, Alexander & Courtney. The firm will continue at the old stand under the name of Alexander & Courtney.

The Swannanoa has been recently fixed up in shape. The new papering in the dining room being especially handsome.

Mr. J. J. Mears left this week for a trip to Nashville, Chicago, Boston and New York.

A copy of the *Asheville News and Hotel Reporter* found in the 1897 time capsule, which was placed at the base of the Vance Monument. *Western Regional Archives Department of Natural & Cultural Resources, Asheville, North Carolina.*

Heather South, the archivist at the Western Regional Archives on Riceville Road in Oteen, was on hand when crews retrieved the mangled box. Prepared for the worst, South had already warned city officials that the contents might not be that desirable. "Nine times out of ten, time capsules end up being sludge because they are exposed to so much environmental issue, and typically they leak and have condensation, mold and mildew. I've probably opened sixteen or seventeen capsules in my career, and most of them have been sludge. You might rescue a piece or a part or find coins or a pin, but documents typically disintegrate."

Much to her surprise and delight, she saw actual paper and documents when the box was opened. Everything was wet, but they were able to successfully dry and salvage every single piece brought out of the capsule. "The only thing I can figure since everything was soaking wet is that everything had expanded. The paper had absorbed the moisture and expanded, and that didn't allow a lot of airflow, so that's why we didn't see a lot of mold and mildew." The bound volumes suffered the most damage. "The leather and adhesives just didn't hold up very well," said South. "While they fell apart, the contents remained pretty intact. The books included were the city code and the Masonic code. They're not rare books. There was also a Bible, again not a rare book, but the fact that it came out of a time capsule is what makes it so significant.

"When we opened that time capsule and saw stuff, it was remarkable for me and it was amazing," she continued. "It was 118 years old when we opened it. I opened a time capsule that was only sixty years old for Montreat, and it was all sludge." Many of the items from the Vance time capsule, including the mangled copper box that once held the contents, are preserved at the Western Regional Archives. The contents are arranged into seven series and include the following:

- Series 1—Monument History: copy of monument history and a program from the dedication;
- Series 2—Masonic Materials: Bible, Masonic Code Book, Asheville Scottish Rite, Grand Lodge of North Carolina Proceedings, Royal Arch Proceedings, and Grand Commandry of Knights Templar Proceedings;
- Series 3—City of Asheville: Charter of Asheville, List of Officers, The Code of Asheville, Roll of Honor of students of Asheville, and Year Book;
- Series 4—Military: Zeb Vance and Camp Vance Muster Roll;
- Series 5—Periodicals: Epworth News, Hotel Reporter and Asheville College Monthly;

Hidden Treasures

- Series 6—Newspapers: Asheville Register, Colored Enterprise, Asheville Citizen, and Daily Gazette; and
- Series 7—Miscellaneous: the actual green-tinged copper time capsule box.

Rare Find

The only known copy of the *Colored Enterprise* still in existence emerged intact from the time capsule. The December 18, 1897 issue was placed in the box at the time of dedication on December 22, 1897. Thomas Leatherwood served as publisher and editor during the newspaper's run from 1896 to 1898. According to reports in the *Asheville Citizen-Times*, Leatherwood opened Asheville's only black pharmacy in the YMI building in 1894. The pharmacy closed the next year, but Leatherwood kept moving forward, using his prior editing experience of the *Freeman's Advocate* in 1892 to launch his own publication.

A rare copy of the *Colored Enterprise*, found in a time capsule placed at Vance Monument in Asheville.
Western Regional Archives Department of Natural & Cultural Resources, Asheville, North Carolina.

Contents of this rare issue included local and regional news items, obituaries, weddings and a front-page article titled "What the Colored Enterprise Would Like to See." It served as a Christmas wish list of things that would benefit the African American community in Asheville. The suggestions included "a graded school established in the west part of the city for the colored youths of that section," that "colored physicians be

recognized by our county coroner" and that "the white people think more of their colored fellow-citizens."

"We were worried there would be negative fallout because Vance Monument can be very divisive within the community, but people were so excited to see the history," said South. "I think the fact that the *Colored Enterprise* was included really started to bring the community together."

2015–2115 TIME CAPSULE

In the year 2115, future Asheville residents will experience the excitement and joy of opening a time capsule that was placed in the base of the Vance Monument to replace the one taken out in March 2015. "A lot of thought went into the next one," said South. "A committee decided what went in. We also labeled it. There's a plaque on the stone that says a time capsule is here and will be opened one hundred years from now. The old one had no identification whatsoever, which is why I think it got lost over the years."

The city assembled a 2115 Asheville Buncombe Time Capsule Selection Panel to wade through categories and suggestions of items to include. That committee was composed of folks from all areas of the community: John Boyle, *Asheville Citizen-Times* reporter/columnist; Heidi Reiber, Asheville Chamber of Commerce; Dr. Kevan Frazier, Asheville Masonic Temple, Mt. Herman Lodge No. 118; Charlie Glazener, Asheville City Schools, Community Outreach; Kathy Hughes, Buncombe County, clerk to the board; James Lee, UNCA Center for Diversity Education, board chair; Beth Maczka, YWCA, executive director; Polly McDaniel, City of Asheville, communications specialist; William Eakins, Historic Resources Commission, commission member; Sasha Mitchell, African American Heritage Commission, chair; Donald Porter, Buncombe County Schools, communications director; Melissa Pennscott, YWCA, communications director; Constance Richards, Public Art & Cultural Commission, commission member; Jack Thomson, Preservation Society of Asheville & Buncombe County; and Ann Wright, Asheville Buncombe Library, North Carolina Room. Heather South served as advisor, and city staff included Debbie Ivester, assistant director of Parks and Recreation, and Brenda Mills, economic development specialist.

Narrowing down the identity of a town as diverse as Asheville to fit into a container the size of a shoebox was no easy feat. As the committee worked on decreasing the proposed inventory, city officials released a survey to receive comments and suggestions from people in the community to allow everyone

a voice in the process. The survey provided a list of categories the committee had focused on and asked respondents to choose their top three, as well as provided space for additional ideas and comments. "We had about two hundred people respond to the survey, and their answers were very similar to what the selection folks had focused on," said Ivester. "The idea is when this capsule is opened, you want there to be stuff in it that will show the people of that time what life was like in Asheville, what was important, what were the values of the community, what was significant," said Ivester. "None of us will be able to sit down and have the conversation with them [in 2115], so how will we be able to visually communicate what life was like? The box is not very big, so we ended up being very selective. We ended up having some things copied on a device. If it wouldn't fit in the box, we put it on a device and kept the actual hard copy in a second set." The second set she referred to is an identical compilation of time capsule contents that is now stored in the City Vault. South had suggested they keep a second set in the event that the time capsule is destroyed in the next one hundred years, but many steps were implemented to make sure it survives. Asheville City Parks and Recreation folks fabricated an airtight, waterproof stainless steel box that will hopefully stand the test of time. It was tested and submerged and didn't leak. South also used modern archival techniques to further preserve the contents.

So, what will folks in 2115 see when the time capsule is once again pulled from the base of the Vance Monument? For starters, there's a touch of the old mixed in with the new. There were silver coins taken out of the 1897 time capsule that were put into the new time capsule. The new version also contains more than just documents after people expressed some disappointment that the original time capsule didn't contain more "things." The 2115 committee decided to remedy that by including beer caps and an eclectic mix of colorful labels from area breweries; bumper stickers such as "Love Asheville: Put Your $ Where Your ♥ Is Go Local," "Keep Asheville Beered" and "Keep Asheville Weird"; an Asheville Tourists' championship ring; police patches; keychains; tourism guides featuring such attractions as Biltmore Estate, the River Arts District and Shindig on the Green; AIR Dining Guide; a postcard featuring a painting by Asheville artist Ann Vasilik titled *Pack Square in Spring*; and other items. Traditional documents were also included. "We took our cues from the old-time capsule," said South. "It had all the major newspaper and publications, so we did the same."

"Heather was a master at making everything fit in that little box," said Ivester.

"That's part of my love of archives—I become part of the story of the records. This time capsule was probably the coolest thing I've done in my career. I've done a lot of cool things and weird things, but the time capsule was amazing," said South.

History Repeats Itself

At 6:30 p.m. on September 18, 2015, a crowd gathered for a formal installation of the new time capsule in the newly restored Vance Monument. Several hundred Masonic Lodge members came and marched from the Masonic Temple on Broadway up to the site of the monument, just as they did in 1897. "They repeated the same ceremony they did in 1897 and followed the same protocol. Local high schoolers sang just like in the original program. They followed all of that pomp and circumstance again," said South.

The *Asheville Citizen-Times* is among the publications with special-edition issues in the capsule highlighting the time capsule. When folks in 2115 pull out the *Asheville Citizen-Times* tucked inside, they'll see an article, "Dear Future: A Letter from 2015 and Asheville Past," written by reporter Dale Neal. In the piece, he reveals a glimpse of Asheville history and decisions currently being made that will help shape the next one hundred years, including the debate on what to do with the so-called Pit of Despair (an empty city-owned lot on Haywood Street across from the U.S. Cellular Center), the new hotels under construction and the issue of whether residents should be allowed to rent out their homes on Airbnb. He described modern-day Asheville with its need for jobs paying a living wage and more affordable housing and also mentioned the I-26 connector that's "still likely a decade away."

This letter to future generations goes on to say:

> *You may shake your head at our decisions, you may think we were foolish in many ways, or wiser back in our time. But after all, you are not much different than us. We are your great-grandparents and ancestors. You are living in the houses we had, traveling the same roads. That probably doesn't help the challenges you face. Traffic. Jobs. Tourism. How to govern yourselves wisely. How to provide for the less fortunate. How to raise your children and grandchildren. How to preserve the goodness of these mountains that hold you as tightly as they cradled us in 2015. And if you are standing here on Pack Square, we've been there before you. Look*

to the southeast; Mount Pisgah still looms on the horizon. You, like us, are still blessed to be here in these oldest mountains on the planet. Perhaps you walk your dogs as we do along the French Broad River, one of the oldest rivers on Earth, even older than the green mountains that surround you. Natives know the pull of these hills. Many more have come and keep coming, seemingly called to make their home in Asheville.

"The time capsule project is the most enjoyable and meaningful I've worked on in my whole career," said Ivester. "The community was so interested, and it was so positive. One of the things we did was called a roll call, where we created some sheets and put them out at all the libraries for people to stop in and sign. We had a little over a thousand signatures, and that was fun to look over those to see how people were interested." They included the original signed sheets in the second archived set of the contents and put a reduced version in the time capsule.

Another Time Capsule

There's another time capsule buried in the Pack Square Park area that will rise to the surface in thirty years. There's a marker on the site of where the capsule is buried at 121 14A College Street and headlined, "Time Remembered." The text on the bronze plaque reads, "The time capsule honoring Asheville's people is buried beneath the plaque to commemorate the city's bicentennial, observed in 1997–1998. The citizens of Asheville's accomplishments over the first two hundred years form the foundation upon which we continue to build tomorrow. The stored keepsakes in the time capsule will be revealed in 2047. Placed by the Webb family in memory of Charles A. Webb, 1866–1949."

Webb had a distinguished career as a lawyer, U.S. marshal and North Carolina state senator representing Buncombe County as a Democrat in 1903, 1905 and 1907. He also enjoyed a successful newspaper career; he bought the *Asheville Gazette-News* in 1916 and renamed it the *Asheville Times*. In 1919, he partnered with George Stephens of Charlotte to acquire the *Asheville Citizen*. Webb ultimately sold the *Times* and devoted most of his time to running the *Citizen*. He bought Stephens out in 1930, teamed up with the then owner of the *Times*, Don S. Elias, and merged the two papers. He served as president of the *Asheville Citizen-Times* until 1949.

Secret Stash

I feel a great sense of responsibility and take ownership of this stuff seriously.
—*Asheville attorney Jim Siemens*

Asheville attorney Jim Siemens knew that he was continuing the legacy of a historic piece of property in Asheville, but he had no idea that hidden secrets would fall into his hands soon after he purchased the Camp Patton-Parker House at the corner of Charlotte and Chestnut Streets. An electrician named German Martinez was working to rewire the historic home for its transformation into Siemens's new law offices when he made a startling discovery on February 22, 2016. As he cut through drywall and plaster, he uncovered a secret overhead compartment housing a time capsule of sorts. Siemens described the location this way: "If you walk through the front door and go down the hallway as far as you can go in the house, you get to a couple of doors to the outside. There was a room built on to one of those doors. If you were standing in that room looking above the door, it's almost like a transom space [where the secret compartment was found]. That's the one space in the house where there's some dead space and that kind of storage is conceivable. I think it was intentional when I look at that space. It was intentionally constructed."

The stash included a treasure-trove of historical documents, correspondence, textbooks and other written ephemera. Some of the most intriguing items included correspondence and papers of Thomas W. Patton, the original owner of the house, and land grants signed by Andrew Jackson in November 1830

and Martin Van Buren in 1837. "They were grants of land in Alabama," said Siemens. "We know that James Patton, Thomas's dad, was involved in cotton plantations in Alabama, and we also know that Thomas, during a furlough from the Civil War, married a woman from Alabama whose family was into cotton. He built the house [in Asheville] in 1868–69 after the war and after the death of his wife and after returning from a failed experience in farming cotton. So that's the Alabama connection."

The metal box that held the land grants also contained letters between family members and friends, Confederate IOUs and financial documents.

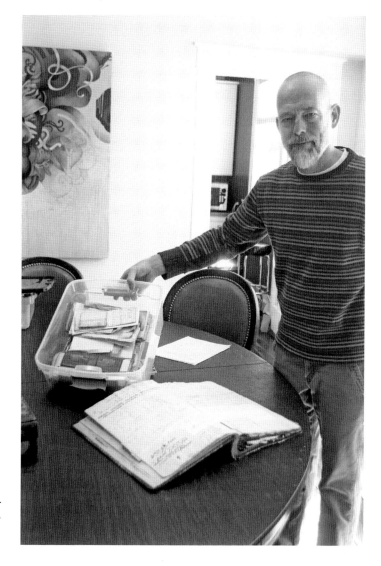

Asheville attorney Jim Siemens shows a box of documents found during renovations on the Patton-Parker House. *Photo by Marla Milling.*

Items retrieved from a secret ceiling storage space in the Patton-Parker House on Charlotte Street. *Photo by Marla Milling.*

When I arrived at Siemens's home, located just a few blocks from the Patton-Parker House, on a sunny Sunday afternoon in April 2016, the contents were spread out on his dining room table. The metal box was surrounded by a half dozen or so plastic storage containers filled with books, letters and ledgers. There was also a chess/checkers/backgammon set and a sailor's journal that detailed a year at sea from 1799 to 1800. "We don't know who the sailor was, but he started making entries in December 1799. He was primarily on the USS *Patapsco*. That boat was launched in 1799 in the quasi-war with France," said Siemens. "In the back of the journal, he has sketches of the islands that

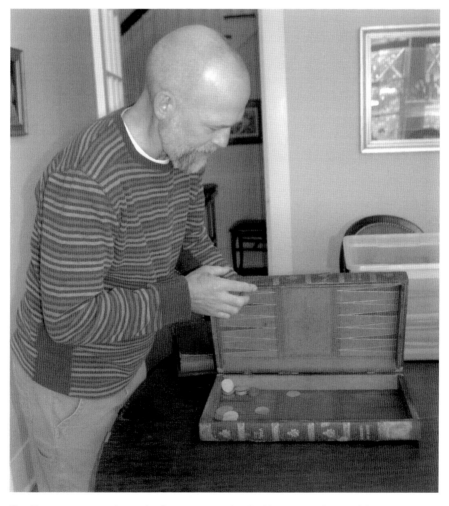

Jim Siemens opens a vintage backgammon set that had been secretly stored for decades. *Photo by Marla Milling.*

they passed and he's also teaching himself trigonometry and navigation by the stars. There are all kinds of diagrams. I'm guessing, but I'd say the sailor was one of James Patton's relatives. One of his brothers probably."

The contents also reveal documentation about what life was like in Asheville in the 1800s. "Patton kept receipts related to his business transactions that they're in great shape," he said. "They probably pertain to the house I own now, but also to homes he was building. It will take a while to go through it all and pull together that story. Another fun book is a registry of the Asheville Club. That registry covers about eight years of guests to the club. They came from all over the country and all over the world. Lots of military figures. Some reverends. Some doctors."

So, who put the books in the ceiling? Since there are books and textbooks with copyrights in 1912 and 1917, someone besides Thomas Patton stored them there, as he died in 1907. It's possible that it could have been a multigenerational effort to preserve different papers, but that part of the story isn't currently known. At some point, the compartment was sealed.

Siemens said that the exciting find makes him feel connected to Asheville in a way he's never felt before. "I love this place," he said. "I've lived here for twenty-two years, but I've never been so grounded in the history of the place. I've never taken the time to think what life would have been like in

Scrapbook found in the Patton-Parker House during renovations. *Photo by Marla Milling.*

Attorney Jim Siemens holds up a handwritten note found in a box of documents hidden in a secret ceiling compartment. *Photo by Marla Milling.*

Vintage textbooks found in a ceiling compartment temporarily stored in plastic bins. *Photo by Marla Milling.*

post–Civil War Asheville. At this point, I know more about the Pattons and the Parkers than I know about my own family history. We're still trying to understand what we have here, but it will be available to the public. If I could afford to display it in some way in that home, I'd love to do that. I will make everything available to the library to digitize."

While he's dedicated to preserving the history revealed in the compartment, he's also devoted to preserving the house itself. The home, entered in the National Register of Historic Places on August 9, 1982, became a City of Asheville Local Landmark on March 28, 2000, and stayed in the same family for seven generations, ending with Mary Toole Parker, who lived in the house until her death at age ninety-seven in 2012. "Mary was involved with the Preservation Society of Asheville and Buncombe County and the Preservation Society represented the family when the property was marketed," Siemens said.

> *The Preservation Society put easements on that land before I acquired it. So I'm actually bound to preserve the building and the grounds. The only place I'm permitted to build is on the back corner of the property where there were historically servants' quarters. So we'll put an accessory building*

Handwritten figures on letterhead of the Asheville Electric Light Company. *Photo by Marla Milling.*

or an annex in that general vicinity where there was a structure. The other thing that's notable about the back of the house is that there is an existing kitchen foundation, and I would love to bring that back at some point. If the space functions for events and I could justify the expense of an outdoor kitchen, I'd do it. Seems like the perfect spot for it. The house has a heart and a soul to it, and I feel very fortunate to be a part of it. It will be a grand law office. I see how the upstairs will function as offices and the downstairs will function as conference spaces. We'll have two, maybe three, conference spaces, and they'll all be grand.

Siemens isn't a stranger to having a connection to unique Asheville history. He bought his home on Washington Road in October 2011. Built in 1912, he said, "It's renowned as the home of Cecil B. DeMille and, later, Charlton Heston. I have sort of stumbled into good things. I feel like I have a charmed life in Asheville."

Thomas Walton Patton Revealed

The history of the Patton-Parker House begins to come to life when investigating the life of its builder, Thomas Walton Patton. Born in Asheville in 1841, he served as a captain in the Confederate army during the Civil War from 1861 to 1865, He served as mayor of Asheville in 1893 and 1894. In a blog post published by the Friends of the North Carolina Room at Pack Memorial Library, it is noted, "Like his grandfather James Patton and his father James Washington Patton, T.W. Patton took his civil responsibilities seriously and promoted modern conveniences which benefited the Asheville community including trolley cars, electric lights, and water and sewer systems. He sponsored municipal institutions—the public library, the home for orphans, the home for destitute young women, the YWCA and the YMCA."

Patton was known for keeping the words flowing in letters and diary entries. Even in the last year of his life in 1907, he documented his observations of the events and people of Asheville and Western North Carolina. In information found at the North Carolina Room, the biggest event that held his attention in that year was an election on October 8, 1907, in which Asheville residents voted in favor of prohibition. There were 1,274 votes in favor compared with only 425 against. His journal entries included the following:

> *October 5, 1907—"Great Prohib* [prohibition] *parade—antis hold meeting at night—Prohibs sure to win I fear."*
>
> *October 7, 1907—"Much excitement about tomorrow's election—but I hope it will go off quietly."*
>
> *October 8, 1907—"Election over—bad conduct on part of prohib ladies—very distressing—majority for prohib reported 800–848."*

Women were not allowed to vote at that time, but they showed up, in large part to make sure their husbands voted for prohibition. Newspaper reports said that women and children wearing white ribbons blocked the way to the polling place. If they spotted a man with a red ribbon—which signaled support for legal alcohol—they surrounded them. As the *Asheville Gazette-News* reported, "From the Opening Hour, Every Voter Was Besieged by Women and Children."

Thomas Walton Patton. *North Carolina Collection, Pack Memorial Library, Asheville, North Carolina.*

One Man's Junk

I didn't want the pages to end.

–Zoe Rhine

Zoe Rhine, the librarian overseeing the North Carolina Room at Pack Memorial Library, didn't know what to expect when an interesting package landed on her desk in January 2015. The cardboard box was secured with white and pink polka-dotted tape. Scrawled across the bottom, the sender wrote in black ink, "Please do not bend," followed by a smiley face emoticon. She would never have predicted that what she pulled out of this funky package would create a flurry of excitement and appreciation in the library.

A woman named Lucy Menard, a school librarian in Albany, New York, had bought a box filled with a variety of ephemera in 2013. She was intrigued by the Albany-area cards, stationery and playbills. One item didn't seem to have an Albany connection, and as she looked at it, she thought someone at Pack Library might want to receive it. This item was a scrapbook of sorts—a collection of thirty-four black-and-white prints of Asheville entitled "Asheville: The Mountain City in the Land of the Sky, Illustrated," and dated 1904.

Opposite, top: Vintage photos of Asheville showing Patton Avenue from the Square and the post office. *North Carolina Collection, Pack Memorial Library, Asheville, North Carolina.*

Opposite, bottom: Photos of Asheville's old library building and the former city hall. *North Carolina Collection, Pack Memorial Library, Asheville, North Carolina.*

Hidden Treasures

Library Building

City Hall

North Asheville ME Church. This church was built in 1903 and stood at the corner of Chestnut Street and Monroe Place. *North Carolina Collection, Pack Memorial Library, Asheville, North Carolina.*

The Colored School in Asheville. *North Carolina Collection, Pack Memorial Library, Asheville, North Carolina.*

When Rhine pulled the photos out, she was amazed that there were shots of Asheville she had never seen before. "I was the only one on the desk at the time when the envelope arrived," she said. "So I opened it and started going through it, and I couldn't wait to keep turning pages. A lot of scenes were shot from the street, giving a strong feeling like you were there. It was incredible to see the people in the pictures."

She pointed to a picture of a church, identified in ornate handwriting as the North Asheville ME Church. "It was designed by famed architect Richard Sharp Smith. We'd never seen a photo of this before," said Rhine. Historical records show that the Methodist Episcopal church was built in 1903 at Chestnut Street and Monroe Place. The African American congregation sold the property in the 1930s to fund a larger building on Hillside Street. This church was demolished. "There's also a photo of the Colored School that burned," she said.

From Albany to Asheville

I tracked down Lucy Menard through Google and talked with her by phone about how she came across the photos. "I found a box of paper ephemera sitting outside a salvage shop," said Menard. When she inquired within, the staff said they hadn't gone through it yet. She told them it was sitting outside and would be ruined in the predicted rain. "I offered five bucks for it, and they took it," she said. "The only thing not related to Albany was

Men standing on the corner in downtown Asheville in the early 1900s. *North Carolina Collection, Pack Memorial Library, Asheville, North Carolina.*

the photo album. I found a number for [Pack Memorial Library], and I called. Whoever I talked with said they would need to see it and asked me to e-mail some photos." The e-mail bounced back, and the album sat forgotten for quite some time. "Finally, one day I was cleaning and came across the album. I thought, 'Well, they didn't seem to care too much about it, so maybe I should chuck it.' But then I thought it is a cool book, so I just sent it down. I got the address off the website, and I pulled two pieces of cardboard out of the recycling bin and wrapped it in duct tape," she said. "It turned out to be quite a find."

Searching for Clues

The discovery of the album led to one big question: who was the photographer? Rhine said that it was apparent from looking at the quality of the shots that it was a professional photographer behind the camera. "We tried everything we could think of to identify this person, including trying

to match the handwriting under the photos," said Rhine. They eventually solved the mystery after finding a duplicate of one of the photos in their archives. That photo of Pack Square was credited to photographer James Melton McCanless. His photography studios were located near Pack Square from about 1890 to 1920. He was known for his Asheville-area landscapes, as well as intimate portraits and group shots.

Additional confirmation came when a staff member at the library found a bound volume that had once been stored in the vault. The burgundy hardcover book had "Illustrated Asheville 1904" listed on its spine. Inside were many of the same shots. There's a business listing for J.M. McCanless, but it doesn't say that he took the pictures in the book. However, a panorama of Asheville contained in the album also appears in this book, and J.M. McCanless is credited with the picture.

An article in the Carolina Public Press revealed details on what life in Asheville was like during the time the photographs were taken: "As it entered

Panoramic view of Asheville in the early 1900s. Photo by J.M. McCanless. *North Carolina Collection, Pack Memorial Library, Asheville, North Carolina.*

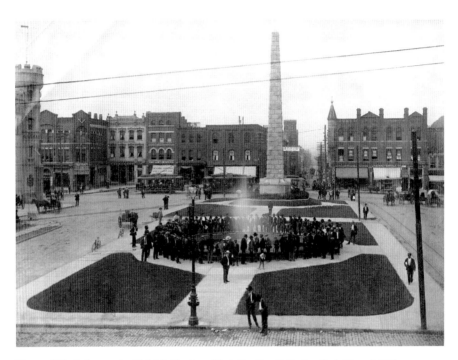

Photo of Pack Square by J.M McCanless. *North Carolina Collection, Pack Memorial Library, Asheville, North Carolina.*

Vintage Asheville photo showing a lot of activity downtown. *North Carolina Collection, Pack Memorial Library, Asheville, North Carolina.*

the 20th century, the town had a population of about 14,600. By 1904, it could boast of having three banks, six schools and 20 churches, along with nine miles of paved roads and 14 miles of electric streetcar lines."

Flea Market Treasure

I now believe it will be part of Asheville history—Billy the Kid will have an Asheville connection.

—*Asheville attorney Frank Abrams*

Sometime around 1880, five gruff-looking men sat down for a photo. The somber-faced, motley crew looked rough and ready for trouble—one even posed with his pistol in his hand and a cigar clenched in his teeth. Another seemed more playful, holding a bottle beside his face, with perhaps a cigar laced in fingers of the other hand, held close to his cheek. In this old tintype photo, the men's cheeks were painted with a pinkish color and the image sealed with varnish to help preserve it.

In 2011, Asheville attorney Frank Abrams caught his first glimpse of the tintype that resulted from the photo shoot some 131 years earlier. He spotted it displayed at an outdoor booth at Smiley's Flea Market in Fletcher, North Carolina. As a collector of vintage cameras and old photographs, Abrams was intrigued by the rough-looking cowboys, as well as two other tintypes featuring a woman in a luxurious dress and another showing an apparently wealthy man dressed in top hat and lavish attire. He asked the sellers about the tintypes and was told that they had come from the famous Root estate in Upstate New York. Abrams paid ten dollars for the three. Then, as he walked around the flea market, he decided to go back and buy two more featuring a man on a horse and a little girl on a bicycle. At home, he displayed the tintypes in a simple frame and hung on a wall outside a

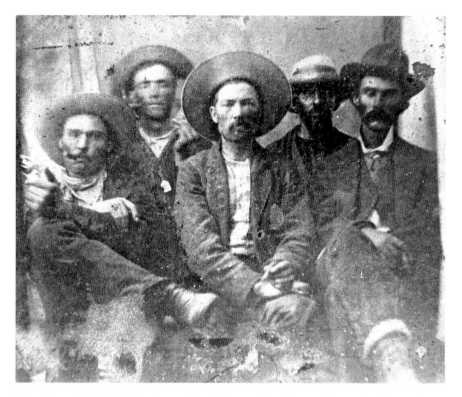

The tintype that Asheville attorney Frank Abrams bought at a flea market. It may be a rare photo of Billy the Kid and Sheriff Pat Garrett, as well as outlaw Dirty Dave Rudabaugh. *Frank Abrams.*

guest room in a section of his house reserved for people who booked nights through Airbnb. Little did he know at that time that the photo his guests were seeing of the rough-and-tumble cowboys might become one of the most famous photographs in history.

Turning Point

Abrams had often joked with his wife, Christina, that maybe the tintype of the cowboys was a rare Jesse James photo. After selling their house and downsizing to move to another, she suggested offering them for sale on eBay. They were unique images, after all, and might attract the eye of a collector. They ultimately decided to hang on to them, which proved to be a wise

decision. In October 2015, news exploded about the discovery of a rare photo at a junk shop. Randy Guijarro reportedly paid $2 for the image in 2010. After years of authentication, the news broke of it being a photo of the outlaw Billy the Kid playing croquet. It's been valued at $5 million.

Talk of the jaw-dropping photo of a Wild West outlaw definitely caught Abrams's attention. The first thing he did was Google "Billy the Kid," and as he scrolled through the information, he almost fell out of his chair when he saw a picture of Pat Garrett. Garrett was linked to Billy the Kid because even though he was reportedly a friend of Billy, he was the lawman who gunned him down in July 1881.

It's important to point out that as a federal and state criminal defense attorney, Abrams has become an expert at analyzing discovery for legal cases, including meticulously inspecting video and photographs to connect the dots and piece together information to take to trial. He knows how to look at photographic details with a discerning eye, and he felt certain that the picture he was seeing of Pat Garrett online matched one of the men in his cowboy tintype.

"Not only was it Pat Garrett, but he was wearing his trademark hat and had his trademark mustache," said Abrams. "I sent it [a scan of the picture] off to the Billy the Kid Museum in N.M. [The director]

Asheville attorney Frank Abrams uses a magnifying glass to look at markings on an old tintype he bought at Smiley's Flea Market. *Photo by Marla Milling.*

immediately got back and said, 'I am 95% sure that it is Pat Garrett. Where did you get this?'"

Getting confirmation of Pat Garrett in the photo led him to scrutinize the other faces. Could Billy the Kid be in the same photo? At the time of this writing in September 2016, it's been a fast ten months for Abrams since making his discovery of Garrett. Since then, he's consulted experts, shared scans and traveled to New Mexico, New York and California in search of answers to the puzzle. He's compared a famous picture of Billy the Kid with the man in his tintype who demonstrates a playful attitude, and it's a close match, right down to the bulging Adam's apple and signature sweater he was known to wear. Abrams has also received preliminary confirmation on Billy the Kid from a top forensic expert. While authentication is ongoing, he remains patient and says, "I have to build my case as it comes."

The man in front clutching his pistol is believed to be Dirty Dave Rudabaugh, a notorious Wild West cattle rustler, train robber and killer who earned his moniker for rarely bathing and wearing filthy clothes.

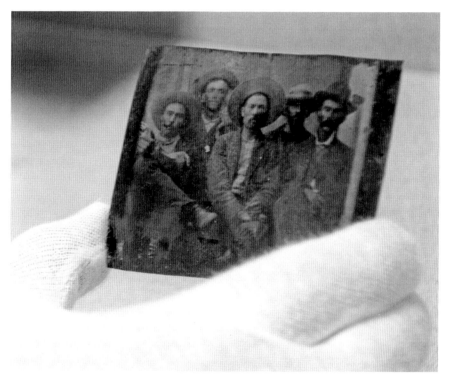

An old tintype found at Smiley's Flea Market in Fletcher, Noth Carolina, may be worth millions. *Photo by Marla Milling.*

"Rudabaugh was the only outlaw chased by Wyatt Earp, Bat Masterson and Doc Holliday," said Abrams. If it is Rudabaugh, it would be the last photo taken of him alive before he was allegedly killed and decapitated and his head photographed on a pole. The man in the middle of the tintype is believed to be Barney Mason, who rustled cattle with Billy the Kid.

There's speculation that it could be a shot from the January 14, 1880 double wedding of Pat Garrett to Apolinaria Gutierrez and Barney Mason to Juana Madril. "If someone had said there's a photo of Pat Garrett, Billy the Kid, Dirty Dave Rudabaugh, Barney Mason and someone else, okay, but no one even knew it existed," said Abrams. "The odds of finding this picture are lower than winning the lottery ten times in a row." The tintypes no longer hang in a modest frame in his home. Instead, they are safely stored in plastic sleeves inside a safe deposit box at Abrams's bank. He only handles them after putting on white cotton gloves.

Connecting the Dots

Looking back at the five tintypes Abrams bought, there didn't initially seem to be a connection between the cowboys and the finely dressed man and woman, man on a horse and child on a bicycle. But he's discovered that all of the pictures provide clues and help tell the overall story. Abrams has found out quite a bit about the people he believes are in the other images. The image of a woman in an expensive dress matches up well with Florence Muzzy. She was married to the richest man in Bristol, Connecticut. Her father and grandfather were both clockmakers, and Abrams pointed out that she's wearing clock gear earrings in the photo. It's possible that her daughter is the little girl on the bicycle. More importantly, her uncle, Ash Upson, was a journalist who went to New Mexico after his divorce and stayed with Billy the Kid's family. "He knew Billy's mother," said Abrams. Upson also became friends with Pat Garrett, and the two of them teamed up to write *An Authentic Life of Billy the Kid*. "It was a whitewashed story," said Abrams. "Upson wrote that Billy was a desperado and Garrett saved the day."

Abrams believes it's Upson who is riding the horse in one of the five tintypes. He pointed to a hump under his jacket below his left shoulder. He then showed that same distortion in a known photo of Upson. Abrams flipped the tintype over and says, "Look right here on the back. It's been scratched with

Hidden Treasures

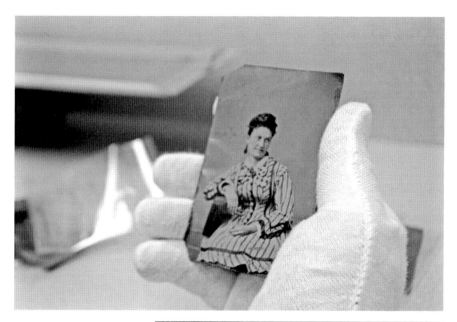

Above: An old tintype that Asheville attorney Frank Abrams believes is a photo of Florence Muzzy. *Photo by Marla Milling.*

Right: A tintype of a young girl on a bicycle. *Photo by Marla Milling.*

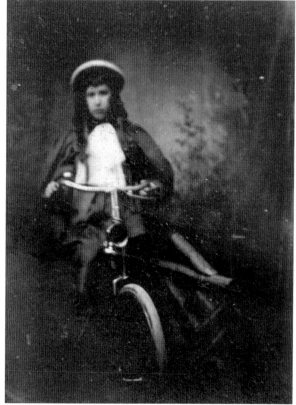

Left: Cover of *An Authentic Life of Billy the Kid* by Pat Garrett. *Library of Congress, Prints and Photographs Division, Washington, D.C., 20540.*

Below: Attorney Frank Abrams has investigated this tintype and believes it to be an image of Ash Upson. *Photo by Marla Milling.*

the letters *a-s-h*. Ash. Jim Brake of the Billy the Kid webpage was the first one to see that, and then we found the writing on the others." He produced a large poster-sized print of the cowboy tintype to point out where, in an extremely small etching, he can see the words "Billy the Kid" written on one man, "Dave Rudabaugh" written above the gunslinger and some other markings. The words are not used for authentication because anyone could have etched them on the tintype at any point, but it does provide Abrams with a further clue that these men may well indeed be Billy the Kid, Dave Rudabaugh, Pat Garrett, Dave Rudabaugh and Barney Mason.

One of the experts, Arizona State University professor Robert J. Stahl, discovered a clue about the tintype of the man wearing a top hat when he met with

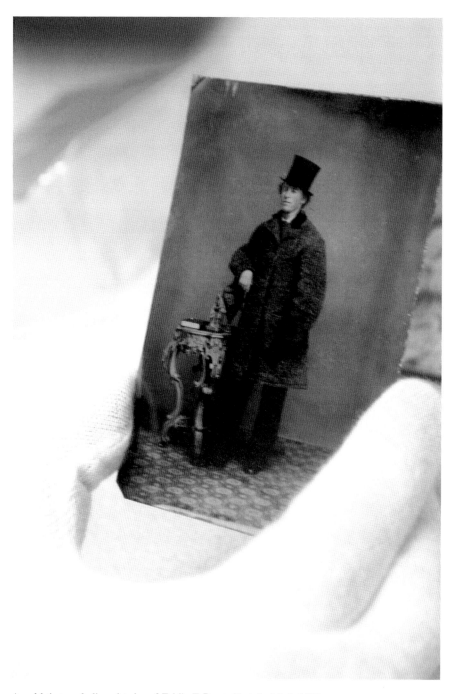

An old tintype believed to be of Eddie F. Root. *Photo by Marla Milling*

A note and calling card found tucked behind the tintype possibly showing Eddie F. Root. *Photo by Marla Milling.*

Abrams. He found a handwritten note that read, "This came from Clinton, N.Y. perhaps a member of Elihu Root's family," along with a calling card with the name "Eddie F. Root" tucked behind the tintype. Elihu Root had a distinguished career as a lawyer, secretary of war (1899–1904), U.S. senator from New York (1909–15) and recipient of the Nobel Peace Prize in 1912. The sellers at Smiley's Flea Market had mentioned the tintypes coming from the Root estate, and Abrams has since learned that someone in Upson's family married into the Root family, thus connecting the tintypes together from a wealthy family to the journalist Ash Upson, who knew a band of Wild West outlaws and lawmen. Perhaps the tintypes were put back for safekeeping, and then, over time, other generations failed to recognize the significance of the people in the pictures. It's impossible to know where the pictures have been for decades or how they ultimately wound up at a North Carolina flea market. It's also possible that there's a twin tintype of this image out in the world somewhere. The type of camera used to take the picture had four lenses and could have produced four identical images or two images—if three holes were covered, it might have produced just one.

Looking Ahead

The big question that everyone asks is, "What's it worth?" There's a lot of speculation and guessing, as well as deniers who say that Abrams is chasing a

pipe dream because they don't think the tintype is authentic. His experience as a criminal defense attorney has given Abrams a thick skin, so he doesn't let the naysayers throw him off track. What he's focused on is finding clues and getting in touch with experts who can make an accurate determination.

If it really is Billy the Kid, this one picture could make for an easy retirement:

> *I hear everything from "Well, it might be worth a few million to $10 million and on up." No one even knew that Garrett took a picture with Billy. It's like having Abraham Lincoln and John Wilkes Booth in the same picture. It's that improbable. There are also people who claim, "They say Garrett was his friend, but that's not true." But it is true. I have the picture. Some will also say Garrett was a good guy. Well, here he is in this picture with two of the most notorious outlaws of the Old West—Dirty Dave Rudabaugh and Billy the Kid. A wealthy cattle baron named John Chisum had approached Garrett and said you need to stop this cattle rustling and you can do it because you're friends with these guys. You can't send a stranger into that place. Garrett had a reputation and he knew where they were, so he was the most likely person. They had to convince him, and*

Attorney Frank Abrams has another claim to fame. He created the banjo-tam. *Frank Abrams.*

finally he agreed. I have a book called The Tragic Days of Billy the Kid, *and in it Garrett spoke to several people and said, "I tried to talk them out of it, and we got together and gambled." This picture was either taken then or it was at a wedding.*

If the photo is proven to be a rare shot of Billy and Garrett together, Abrams laughs about the thought of being named on Billy the Kid's Wikipedia page. The reason he finds it so humorous is that he is already named on a totally unrelated Wikipedia page. If you go to "banjo" on Wikipedia, you'll find him there. Under the subheading "Banjo hybrids and variants,' it reads, "A recent innovation is the patented Banjo-Tam, invented by Frank Abrams of Asheville, North Carolina, U.S. Patent No. 6,156,960. It combines a traditional five string banjo neck with a tambourine as a rim or pot."

Thrift Shop Treasure

Another valuable treasure emerged from a Goodwill Outlets store at 1616 Patton Avenue in Asheville. While Goodwill has many retail shops in the region, its outlet store features items in bins that are priced by the pound at the cash register. A couple from Knoxville, Tennessee, Sean and Rikki McEvoy, were digging through bins of clothing in June 2014 looking for items they could resell in their vintage clothing store, Roslyn VTG Trading Co. They found an old West Point sweater, and even though it had a few moth holes, they felt it was a good deal at fifty-eight cents.

I tracked down the McEvoys through their Etsy shop and communicated with Rikki by e-mail. She pointed me to a *Personal Effects* podcast where she and Sean had talked about the discovery. When they bought the sweater in Asheville, they put it on a repair pile at their home. One day, she inspected the sweater and was trying to find the right thread to repair the moth holes. Suddenly, her gut instinct kicked in. As she revealed on the podcast, "I just had the feeling that I need not touch this; need to not change it or alter it or anything. It was kind of weird because I'd never had that kind of feeling about anything before." The very next day, Sean was watching TV in their bedroom and had flipped to a documentary about legendary football coach Vince Lombardi on HBO. He coached at West Point from 1949 to 1953. "I walked in the bedroom right at the point they were showing a picture of Lombardi standing there with his West Point sweater on, and I

West Point sweater found at the Goodwill Outlets on Patton Avenue in Asheville. *Heritage Auctions, HA.com.*

was like 'Wow! That's the same sweater we have.'" Sean jokingly asked if his name was in it, and she told him that yes, there was a handwritten label inside with the name "Lombardi." Sean said, "I didn't know if it was going to be worth $1,000 or $200,000. I felt like there was an aura around it. It felt special from the time we found it. I've found stuff that was valuable before, but not like that."

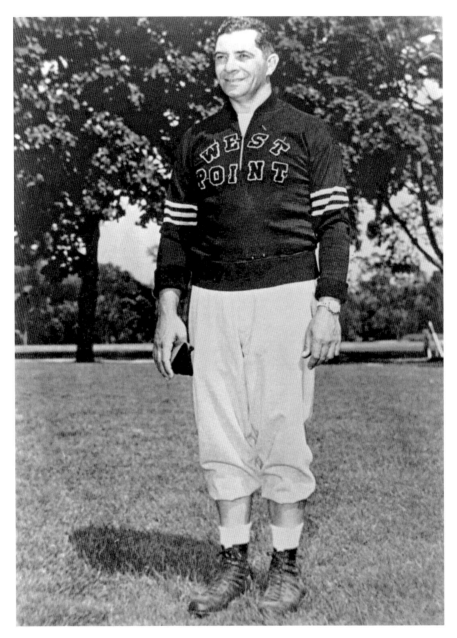

A sweater that once belonged to Coach Vince Lombardi sold for $43,020 at auction. *Heritage Auctions, HA.com.*

Label identifying the sweater as the one that belonged to Coach Vince Lombardi. *Heritage Auctions, HA.com.*

After the sweater was authenticated as the one Lombardi wore, the McEvoys put it up for sale in New York City through Heritage Auctions. It brought in a whopping $43,020 in February 2015.

Heritage Auctions released a statement after the sale saying that Ann Wannamaker, the widow of Bill Wannamaker, had donated the sweater to Goodwill. Wannamaker served on the West Point coaching staff with Lombardi. The auction company said, "In light of the new revelations that trace the history of this important sports artifact back to its owner for the past six decades, Heritage Auctions is pleased to donate the seller's commission of Lombardi's West Point sweater to Goodwill in memory of Bill Wannamaker, at the request of the Wannamaker family."

No Coincidences

Mark-Ellis Bennett, who is a restorative artist and historian at the Asheville Masonic Temple, has a fun story about a special find he discovered at the now-only-a-memory Dreamland Drive-In on Tunnel Road, the former site of weekend flea market sales. Lowe's stands on the site today. At one point, he was hired to do restorative painting at the Grove Park Inn and was working in the Palm Court area when he identified a crack on the balcony side of the wall. "The general manager wanted me to fill in the crack and paint over the wall," said Bennett. He was instructed to get a key so he could get into the maid's closet at night, where the brushes were stored. He went to the key shop at the Grove Park Inn, and while the man was cutting the key, Bennett asked about four skeleton keys he spotted hanging in a cabinet. He was told they were original guest room keys and not for sale. Bennett said,

"That's okay. I bet I'll find one at a flea market. That was on a Wednesday. On Saturday, I was at Dreamland Flea Market, and there was a man with a big brass tray full of skeleton keys. All had three-digit numbers on them." When he asked about them, the man said they were from the Grove Park Inn. He had been a painter there when they changed the locks. Bennett bought the whole lot.

"Three days after I said I'd find one, I found not just one, but seventy," said Bennett. He thought about selling them, but then he considered a plan to preserve their historical value. He drew up a document and offered to gift sixty-eight of the keys to the Grove Park Inn if it would permanently display them in the Palm Court. The general manager agreed. "They were mounted over the crack in the wall, so I got to save that wall," he continued. As for the remaining two keys, "I have one on my key chain," he said. "I gave the other to Bruce Johnson." Johnson is a noted Asheville author and founder of the National Arts & Crafts Conference at the Grove Park Inn. The conference in February 2017 marked its thirtieth year.

PART III

LEGENDS OF THE RICH AND FAMOUS

Rock-and-Roll Fantasy

If you ride the LaZoom bus, they talk about me every time they go past the Civic Center. I've been on the bus two or three times, and they didn't know who I was.
—Mike Harris

An Asheville man is part of rock-and-roll history, and his story can be summed up as simply being in the right place at the right time. When twenty-one-year-old Mike Harris took his seat in the Asheville Civic Center on July 23, 1975, he was already feeling the kiss of serendipity. Elvis Presley was in town for a three-night concert run, and his girlfriend's parents had offered them tickets. Mike and his girlfriend, Debbie, who is now his wife, were students at Western Carolina University, and even though they were taking summer courses, their schedule was free to drive to Asheville for the Thursday night concert. They had no idea they'd have front-row, center stage seats providing a close-up view of the "King of Rock-and-Roll." More importantly, Elvis had a close-up view of them.

Speaking of getting "All Shook Up," the shock of Harris's life came just as the show was getting started. Harris said that prior to Elvis striding onto stage, the "place went as black as I've ever seen it. You could hear the rumble of the kettle drums and bass guitar, and here he came. You don't expect to ever see someone up that close like him. He was big as life right there. During the opening number, Elvis walked out, walked across the stage, pointed at me and said, 'Come here.' He handed me the guitar, and from there it was all a blur. All I could think of was, 'How am I going to get out

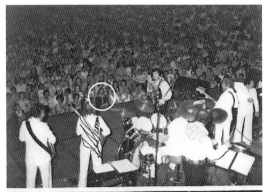

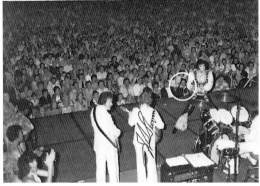

Mike Harris, seated in the front row of an Elvis Presley concert in Asheville. Elvis presented him with his Gibson Dove guitar. *Mike Harris.*

of here?'" said Harris. Elvis also later called him up on stage and told Harris that he was giving him the guitar for a reason. That reason is something Harris has never figured out. "I don't know why he picked me out unless he liked the leisure suit I was wearing at the time."

The guitar Elvis handed him was a prized possession gifted to him by his father, Vernon Presley. The Gibson Dove guitar was originally blond when Vernon plunked down $964 for it at a guitar store located across the street from Graceland. The check Vernon wrote for the guitar was made out to Mike Ladd's Guitar City and dated September 9, 1971. It's catalogued in the Graceland Archives. He then took it to Gruhn Guitars in Nashville, where the staff transformed it into a black guitar to honor the black belt Elvis earned in Kenpo Karate. The guitar itself was produced by Gibson in 1969. "Gruhn Guitars in Nashville took the guitar apart, painted it black, put the mother of pearl inlay in the neck. They did all this custom work to it and then put the Kenpo Karate seal on the front of the guitar and shellacked it to seal it in," said Harris.

The guitar was widely photographed with Elvis and appeared on five album covers. One of the most famous appearances with the black Gibson Dove was the *Aloha from Hawaii* concert, which was broadcast globally by satellite on January 14, 1973. Graceland Auctions literature about the guitar notes:

> *There is no more important icon of rock 'n' roll history than Elvis' beloved Gibson Ebony Dove. The Dove is a flattop steel string acoustic guitar with*

solid maple back and sides, and a solid spruce top. The double-ring rosette styling with seven and three-ply binding adds an understated elegance. The black pick guard has a white beveled edge and the adjustable rosewood saddle with mother-of-pearl circles and stylized doze shaped emblems. The rosewood fret board with rolled edges, split parallelogram inlay is also inlaid in mother-of-pearl with the script "Elvis Presley." The crown pegged Gibson logo, also fondly referred to as the thistle, adorns the headstock of the guitar, and a Kenpo Karate decal is affixed to the body. The Kenpo Karate Association of America decal dominates the front of the guitar. It is the hallmark of the organization founded by Elvis' longtime instructor, bodyguard and confidante Ed Parker.

After presenting the guitar that evening in 1975, Elvis called Debbie on stage and "wrapped a scarf around her neck and kissed her." Elvis also gave away some diamond rings that night and other scarves and necklaces. "He was in a giving mood that night. He really was, but I was the only one who had anything with his name on it," said Harris. Lloyd Perry was a fan, also seated on the front row, who received a ring from Elvis embedded with nineteen diamonds. He told the *Asheville Citizen*, "I could take it if it were just costume jewelry, but I can't get over him giving something like this away, to a perfect stranger. I ain't felt this funny since I got married." He took it to a jeweler to have it appraised, and they told him he could trade it for a very nice car.

Even though Harris worried throughout the show about leaving safely with the guitar, the Asheville Police Department had the situation under control. At the end, officers escorted Mike and Debbie on stage, out the back door, into a police cruiser and dropped them off where they had parked. "I rode around with it in the trunk for days," said Harris. "I bought a guitar case, put it back in the trunk and drove to WCU. I took it to my dorm and everyone played it."

He stored the guitar in various banks at certain intervals, and if people asked him about the guitar, he would tell them it was in a bank vault. Truth be told, it was most often at his home. "I told people it was locked up in the bank, so they wouldn't come to my house," said Harris. "We would move it from room to room around my house. It would be under a bed or behind a mirror or something. Every kid my kids brought home got to see the guitar." He also taught third graders at Charles C. Bell Elementary for eight years and said, "All those kids had their pictures made with it, too." When *The Hunger Games* movie was in production in the WNC area, executive producer

Robin Bissell rented Debbie's parents' house. "He was a big Elvis fan," said Harris, "so we had our picture made with the guitar."

Whole Lotta Shakin' Goin' On

It makes sense for someone possessing Elvis's famed guitar to take on a bit of his persona, so it's no surprise that Mike Harris has entertained many as an Elvis impersonator. But it's not something he intentionally decided to do. "It all started as a dare," explained Harris. "A friend of mine worked for Lee Greenwood as a producer. Lee Greenwood's band had put together an eight-minute medley [of Elvis hits], and my friend said, 'I think you could do this. You can learn the words to the songs and jump from one to another.' I first did it at church for Family Fun night, and from there it blossomed. When they did the Ingles' Food Show, I became the opening act for all the country stars who performed. I got to meet people like Blake Shelton and Trace Adkins—I met them all."

At one point, Harris was working for a company that scheduled its national meeting in Cancun. "No one in my company knew I did this except for a select few, and they asked me to do this in Cancun." By then, he had a twenty-minute routine, complete with the jumpsuit, wig, glasses and jewelry. "The people at the hotel in Cancun got my name and asked me to come back to perform for other groups. I also did it on cruise ships, the Alabama Theatre at Myrtle Beach and three times in Hawaii at the Don Ho Dome. Some guys get real serious about it, but I'm not that kind of impersonator," said Harris. "I was more into it for the fun, making people happy and making people feel like they were part of the whole show. That's how Elvis was, too. He liked to clown around, joke and cut up. I was very fortunate and blessed to be able to impersonate his voice. I haven't done the Elvis thing in about a year. Not because I couldn't, but because I chose not to. I have a couple shows coming up in October [2016]."

It's Now or Never

For forty years, Harris lovingly cared for the guitar Elvis gave him. He kept the strings changed on it so the neck wouldn't warp. He admired it, took

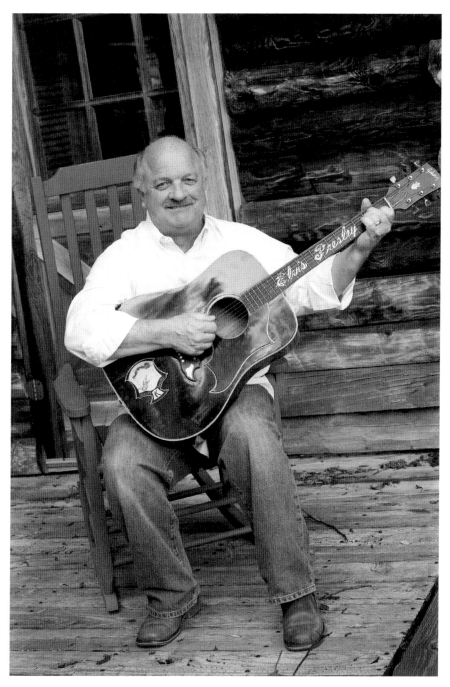

Mike Harris with the Gibson Dove guitar given to him by Elvis during a concert in Asheville. *Photo by Karri Brantley, karribrantleyphotography.com.*

care of it, let friends and family inspect it and reminisced about that magical night in 1975. From the time it became his, a steady stream of auction houses and private individuals approached him about selling the guitar, but he never wanted to make a hasty decision. "I didn't want to sound greedy, but I told them I believed if I hung on to it longer it would be worth more," said Harris.

In May 2015, a man contacted Harris telling him that Graceland had started its own auction house and inquired about the possibility of putting the guitar on display in Elvis's former home and then putting it on the auction block. After lengthy discussions with Debbie and their children, Harris finally said yes. "We talked for a long time," he said. "We asked each other, 'Is this the right thing to do?' 'Is this the right time?' The next generation won't know Elvis and they won't care, so it seemed to me to be the right time. It was hard to give it up. It was hard to see a guy carry it off from here, but that afternoon, he sent me a picture of the guitar in a glass case at Graceland."

The Gibson Dove was listed as Lot no. 24 in an auction at Graceland on January 7, 2016. Expectations were high, with a minimum opening bid of $150,000. Ten bids rolled in, but the auction closed without the reserve being met. While it was disappointing that the guitar didn't sell, Harris quickly got a call from Julien's Auctions in New York City. "He said, 'I can sell that guitar for you at auction.' He told me the last guitar he sold was one of John Lennon's for $2.7 million. He also said, 'You won't get that for an Elvis guitar.' Elvis was known for singing. He had a guitar as a prop."

Harris gave a thumbs up to Julien's, and they flew a staff member to Graceland to pick up the guitar and take it to New York City. They also had it featured on all the networks and other TV shows. On May 21, 2016, Julien's put the Gibson Dove on the auction block as part of its Music Icons 2016 Auction at the Hard Rock Café in Times Square. This time, the reserve was met, with the high bidder shelling out $334,000 for the guitar. "It's a whole lot more than I thought I'd ever see out of it," said Harris. "It was hard to give it up, but now I see there are things that can be done with this money. There are non-profits I'm involved in that I can help. I can give back to the community. It's not so much that I wanted the money to spend, but it lets me give back to the community here."

Harris does still have moments where he misses the guitar. His daughter compiled pictures of the guitar into a photo book and presented it to him for Father's Day. "This was after the guitar was gone, and it really touched my heart," said Harris. "I had my fifteen minutes of fame and did my thing."

That July night in 1975 turned out to be Elvis's last performance in Asheville. He intended to return and was actually booked to play a sold-out concert at the Civic Center on August 26, 1977. Sadly, he never made it. He died ten days earlier at Graceland.

The Hope Diamond's Asheville Connection

It's just a plain piece of rock as far as I'm concerned. I do know that it's very beautiful, but who on earth wants a great big rock like that. It's right where it belongs, in a museum.

–Mamie Reynolds

A few years ago, my son and I had a free afternoon in Washington, D.C., so we made a beeline to the one thing I most wanted to see: the famed Hope Diamond. The exquisite blue gem—at a whopping 45.52 carats—draws constant attention from a steady stream of onlookers at the Smithsonian's Museum of Natural History. The famed stone is surrounded by sixteen white diamonds and hangs on a chain of forty-five diamonds. Little did I know at the time that an Asheville toddler once buried that very gem in a sandbox. It also was attached to the collar of her grandmother's dog. The little girl who played with the Hope Diamond (currently valued at $250 million) was Mamie Reynolds, and her grandmother was Evalyn Walsh McLean. Mamie was the only daughter of U.S. Senator Bob Reynolds and his fifth wife, Evalyn McLean Reynolds, who reportedly ended her life with an overdose of sleeping pills on September 20, 1946, a little less than a month before Mamie turned four years old.

Could her death have been part of the rumored curse that's supposedly attached to ownership of the Hope Diamond? Mamie's son, Joseph Charles McLean Gregory, said that his great-grandmother did not believe in a curse,

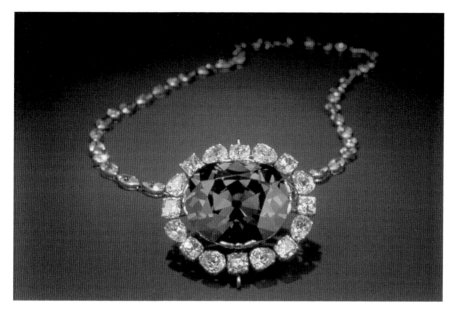

The Hope Diamond, which is housed in the Smithsonian's Museum of Natural History in Washington, D.C. *Smithsonian Institution.*

even though she suffered through many tragedies. An article in the *Asheville Times* on May 1, 1947, noted:

> *Tragedy struck early at Mrs. McLean. Years before she acquired the Hope Diamond she was injured seriously in an automobile crash which took the life of her brother, Vinson Walsh. Then, a few years after her marriage to Edward Beale McLean, son of the multi-millionaire publisher of The Cincinnati Enquirer, their firstborn—called Vincent for her brother—was killed beneath the wheels of a car. By this time Mrs. McLean was the owner of the Hope Diamond. Friends, mindful of the legends of the stone's curse, pleaded with her to get rid of the gem. But she refused. She fretted for a time about the legend of the curse. Then she took the gem to a priest and had it blessed. From that day on Mrs. McLean appeared impervious to the claims of the stone's fateful power, despite the misfortunes which subsequently beset her. But her own marriage broke up in tragedy worthy of Hope Diamond lore. Mrs. McLean charged her husband with adultery and he eventually died in a mental institution, his fortune depleted.*

Evalyn Walsh McLean's father, Thomas Walsh, struck it rich in the Camp Bird Gold Mine in Colorado, and then she also married into great

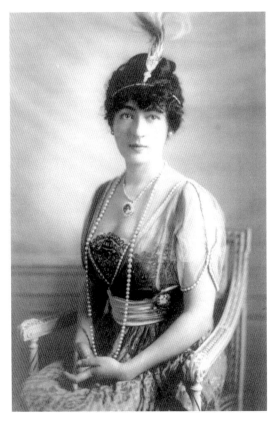

Left: Evalyn Walsh McLean wearing the Hope Diamond, which she bought in 1912 for $180,000. *Library of Congress, Prints and Photographs Division, Washington, D.C., 20540.*

Below: Evalyn Walsh McLean signing copies of her book. *Library of Congress, Prints and Photographs Division, Washington, D.C., 20540.*

wealth. Her closest friends ranged from presidents to movie stars. She threw lavish parties, was very generous to others and even turned over $100,000 for ransom in the Lindbergh baby kidnapping.

I reached out to Joseph after learning about Asheville's connection to the Hope Diamond. He very graciously offered up information about his family and even got a bit choked up, saying, "As long as I can touch people's lives with a story as to what kind of a lady Evalyn was, I did my job." Even though Evalyn Walsh McLean died before he was born, Joseph knows her very well. He's immersed himself in family history and penned *The Hope Diamond* and wrote the foreword for *Queen of Diamonds: The Fabled Legacy of Evalyn Walsh McLean*. He also created Fable Fragrances, inspired by the Hope Diamond.

Evalyn enjoyed wearing the Hope Diamond (she even wore it on her death bed), but she also freely allowed others the pleasure of experiencing it. Joseph said that she would loan it out for charity events or to brides so they would have "something borrowed, something blue." He also said, "She allowed people to wear it so they'd know what it felt like—glamorous, beautiful, exquisite. She allowed people to touch it and wasn't afraid to let people put it on or use it. She let a little girl like my mother teethe on it and play with in in the sandbox and would let her Great Dane, Mike, wear it around the house. She knew she was going to get it back."

Brief History of the Hope Diamond

The Smithsonian's timeline of the Hope Diamond begins in 1668, when King Louis XIV of France bought a spectacular blue gem from Jean-Baptiste Tavernier. It was apparently 112 carats when he acquired it, but he had the gem recut into a 67.5-carat heart-shaped diamond known as the French Blue. In 1749, King Louis XV had the diamond set into the Order of the Golden Fleece by Parisian jeweler Pierre-André Jacqumin. King Louis XVI and Marie Antoinette were captured in 1791 while trying to leave France during the French Revolution. The revolutionary government took control of the royal jewels—including the French Blue Diamond—and housed them in the Garde-Meuble. The jewels were stolen in 1792 during a five-day looting spree.

The stunning blue gem resurfaced in London in 1812—the stone had been recut and now weighed 45.55 carats. In 1839, a blue diamond appeared in the gem collection catalogue of Henry Philip Hope, and from that point on, it's been known as the Hope Diamond. Charles Barbot was the first to write in 1858 about speculation that the Hope Diamond was the recut French Blue Diamond. (This claim was substantiated by François Farge, professor of mineralogy at the National History Museum at Paris. In 2009, he discovered a lead replica of what turned out to be the French Blue. When comparing measurements, Farge and his colleagues could see exactly how the French Blue was cut to form the Hope Diamond.) Lord Francis Hope inherited the diamond in 1887, but debts forced him to sell it in 1901. For the next six years or so, it passed through several gem dealers and ultimately wound up in New York City, where Selim Habib bought it in 1908. The French jewelry house Cartier acquired the diamond in 1910 and began searching

for a buyer. It showed it to Evalyn Walsh McLean and her husband, Ned, but she wasn't too keen on the setting. When Cartier surrounded the gem in a more contemporary setting, Evalyn bought it for $180,000 in 1912.

Evalyn's will left the Hope Diamond to Mamie Reynolds, with a provision that it would be held in trust until Mamie's twenty-fifth birthday in 1967. However, jeweler Harry Winston bought all of her jewelry, including the Hope Diamond, in 1949, just two years after Evalyn's death, in order to settle her debts. That collection also included the 94.80-carat Star of the East, also once owned by Evalyn. Winston created a cross-country exhibition of his most important diamonds and gemstones called "The Court of Jewels," which raised money for local charitable organizations. The tour ran for four years, ending in 1953. George Switzer, a Smithsonian mineralogist, is credited for successfully convincing Winston to donate the Hope Diamond as a centerpiece for a world-class gem collection at the Museum of Natural History. Winston agreed and in 1958 mailed the famous gem to Washington, where it was accepted by Dr. Switzer and Leonard Carmichael, secretary of the Smithsonian. They were perhaps a bit aghast upon discovering that the gem had been mailed in a plain brown paper envelope through registered first-class mail. On its website, the Smithsonian quotes Winston as saying, "It's the safest way to mail gems. I've sent gems all over the world that way."

Intriguing Asheville Girl

Growing up atop Reynolds Mountain in north Asheville, Mamie reportedly had no idea that she was a very rich little girl. In a feature article in the *Charlotte Observer* dated July 10, 1955, twelve-year-old Mamie told the reporter she wanted to appear on the TV program *Strike It Rich* because she wanted to be a veterinarian when she grows up and wasn't sure she can afford it. The article goes on to say, "But Mamie, at age 18, will inherit a tremendous fortune: how many millions only her lawyers and her father know. Her income from trust funds now approaches a half-million dollars a year. It keeps piling up. Because Mamie, plain, unassuming, gentle Mamie, doesn't know she has a dime." Another passage in the article notes, "Mamie, who studies and speaks three foreign languages, has a doll collection and the usual whatnots. Only wall decorations in her pine-paneled apartment, which has cast-iron barred windows consists of two paintings, one of her grandfather McLean's famous race horse, Indian Flower, and the other of Beau, a whippet and her

Senator Bob Reynolds of Asheville. *North Carolina Collection, Pack Memorial Library, Asheville, North Carolina.*

mother's favorite dog. This is the only visible reminder of her mother. There are no portraits of any of the Reynolds wives, only pictures of father and daughter, and a portrait of Reynolds' eldest daughter, Frances, who built the $45,000 house, and is now an artist in Italy."

Chuck Rapp, Joseph Gregory's partner, told me that her father reportedly put bars on the windows because he wanted to protect her from kidnapping. She grew up in a house on Reynolds Mountain surrounded by 250 acres and punctuated by stunning mountain views. The *Charlotte Observer* article described it as "an unpretentious and rustic-modern home of hand-hewn oaken logs and native field stone." The household included her governess, Miss H. Louise Palmer, known as "Mimi"; "Cookie" Louise, who prepared their meals; Mr. and Mrs. Frank Bien, who served as caretakers; and Oscare Reese, stable and farm foreman. In her teens, she purchased and moved with her dad and governess to a home on Vanderbilt Road in Biltmore Forest—a home her godfather, J. Edgar Hoover, personally checked out to ensure it would be a safe place for her.

In researching Mamie, I felt a deep sense of longing—a wish that I could have met her and talked with her about her fascinating life. I do know something about her kind spirit and unpretentious attitude from talking with her son, Joseph, who presents a genuine, kind spirit and an open heart. That speaks volumes for her—that she passed on to her son a love of treating others well, even though her fortune could have led to a different attitude. She told the *Asheville Citizen-Times* in 1962, "I don't try to put on any airs, and I don't feel that I'm better than anybody else. It's not who you are socially, but the way you act and think that's important."

This was also reflective of her grandmother's demeanor. In her book, *Father Struck It Rich*, Evalyn Walsh McLean wrote, "The one outstanding lesson I have learned and the one Father always taught me was, 'Think of the other fellow first.' Human nature is such a wonderful thing; people are so fine and real when you least expect them to be. You see, I really love people, all people and every class of people. Another thing I was taught is, 'Give part of yourself.'" She went on to write, "The real things, I have found out, are quiet and peace in your own soul, love and thought for the people around you, and above all, the care and devotion you give to your children."

Joseph very generously offered to write down some thoughts about his late mother, and I am delighted, with his permission, to include them here.

My Mother's Story
By Joseph Charles McLean Gregory

This is my sister's, Evalyn, and my story about our mother who was life's society fairy tale. We are the only children of Mamie Spears Reynolds Gregory and Joseph Gregory. We are very humble and blessed to have such wonderful parents who taught us about life, caring for animals, and to never take anything for granted. There is a quote that makes my sister and me laugh—My mother would always say, "If you can't afford the real thing, wait till you can."

October 15, 1942, a little baby girl named Mamie Spears Reynolds was born to U.S. Senator Robert R. Reynolds and Evalyn McLean Reynolds. This was a family that shared residences in both Washington D.C. and Asheville N.C. From day one little Mamie was labeled by the press as "the richest little girl in the world." Some would say yes she did have a "rich" life, but others would argue that Mamie's life was simple. Especially when it came to her grandmother, Evalyn Walsh McLean, who was the last and the longest private owner of the infamous Hope Diamond and the owner of the Washington Post and Cincinnati Enquirer newspapers. Evalyn would argue that little Mamie was rich with a full life and love. In Evalyn's eyes, money wasn't everything. The most important thing is how you treat others.

Mamie's life took her on the greatest adventures around the world seven times. As she grew up to become an adult, Mamie had her "coming out parties" from Washington D.C. to New York City and last in Asheville N.C. As Mamie got older she found herself liking race cars and becoming very addicted to them. Her father once said, "If she loves to race cars, why not give it a shot." Well, she took his encouragements and bought seven race cars and had a crew of seven by the end of that month. She was the first woman to qualify for the Daytona 500. Mamie was known by her competitors as the "speed racer." She was always in a rush to get whatever she wanted. This little girl was growing up very quickly. By the time she was 22 years old, she married her first husband, who was the manager of her race team. The marriage didn't last long. To Mamie her first marriage was just a trial run for the real husband she was about to know well.

In the mid sixties Mamie Reynolds had her eye on this gentleman named Joseph Gregory. As Mamie would call it, "Joe was handsome, funny, a hands on person, and someone who had a presence about himself." That's exactly what Mamie liked and wanted her husband to be. Joe Gregory married Mamie in a simple and last minute wedding in Mexico in 1965.

Joseph Charles McLean Gregory with his sister, Evalyn, and his dad, Joe Gregory. Joseph and Evalyn are the children of Mamie Reynolds. *Joseph C.M. Gregory.*

This was supposed to be a get away weekend. It turns out that it was more than a simple vacation. Soon after the wedding was over that week, they returned to Kentucky with a vision to buy a famous ABA basketball team called the Kentucky Colonels. This was great because they shared a common interest. For instances, they both loved basketball, racing cars, living on a farm and dog shows. With all of that set with their relationship, it was a sign that they would become the "magic couple" that people admired.

In 1966 Joe and Mamie had their first son, Joseph Charles McLean Gregory. Then in 1969 the Gregory family welcomed a little girl named Evalyn Reynolds Gregory. Each child grew up knowing about their legacy and always applied action to dreams to make them come true. Just like their parents did.

COMING FULL CIRCLE

On a sunny Sunday in September 2016, Joseph's partner, Chuck Rapp, met me high atop Reynolds Mountain in north Asheville at the home where Mamie grew up. She sold the 250-acre property to a group of developers in 1969 for $225,000. Much of the property has been developed for houses over the years, but there's still about 4 acres or so attached to the Reynolds

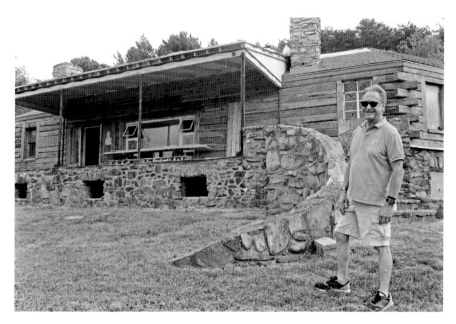

Joseph Gregory's partner, Chuck Rapp, at Mamie Reynolds's childhood home. Gregory and Rapp recently bought the home and are restoring it to its original grandeur. *Photo by Marla Milling.*

home, which was built in 1947 for Reynolds's daughter, Frances, who was born in his first marriage. Her mother died of typhoid fever. A piece of Frances's artwork remains in the house, which was called the Frances Reynolds-Oertling House. She ultimately moved to Italy, where she lived out her life, but she's buried next to her father at Riverside Cemetery.

Joseph was three years old when his mother, Mamie, sold the house, but on November 2, 2015, he and Chuck became the newest owners of the house. They are in the process of restoring it and making it their home base. As Chuck led me through the empty rooms, he told me it was designed by famed architect Douglas Ellington—one of the few houses he created. Ellington is well known in Asheville for designing Asheville City Hall, the S&W Cafeteria Building, First Baptist Church and Asheville High School. They are following guidelines from the Preservation Society to maintain the integrity of the original design, but they have grand plans for making it a spectacular show place filled with such items as a massive portrait of Evalyn McLean Walsh and other family memories.

Renovations began in May 2016 and are expected to last at least through the summer of 2017. There are some charming touches remaining—

"Mamie" scrawled in concrete when she was a child, her tiny footprints lingering in another concrete space, the Reynolds Coat of Arms on one doorway, wormy chestnut kitchen cabinets and intricate stained-glass windows in a room boasting a bounty of built-in book cases. The house, with its sweeping mountain views, is located exactly one mile from the Reynolds Mansion Bed & Breakfast Inn, which was originally built in 1847 by Daniel Reynolds, who was the grandfather of Senator Bob Reynolds.

I stopped in to see innkeeper Billy Sanders at the Reynolds Mansion Bed & Breakfast Inn on a picture-perfect Sunday in October 2016. He and his partner, Michael Griffith, bought the house when it was overgrown with ivy and in pretty bad shape, but they had a vision. Today, the home is beautifully restored to reflect a bygone time. About 80 percent of the furniture inside is original to the time when the Reynolds family lived there. Portraits of Daniel and Susan (Baird) Reynolds are prominent in the main hallway beside a sweeping staircase. There's also evidence of the Hope Diamond legacy: a portrait of Evalyn Walsh Reynolds wearing the necklace her mother owned, family photos of Senator Bob Reynolds and Mamie, an antique display cabinet filled with books related to the Hope Diamond, a replica of the necklace and a Barbie Doll wearing a tiny version of the Hope Diamond.

Mamie Reynolds scrawled her named in concrete along with the year, 1953, at her family home atop Reynolds Mountain in Asheville. *Photo by Marla Milling.*

Mamie Reynolds at home with her father, Senator Robert Reynolds, and her young cousins Pam and Julie Reynolds—the children of Robert Reynolds Jr., who died in a car wreck. Mamie is standing beside Pam. Julie is sitting. *Reynolds Mansion Bed & Breakfast.*

This house also features a commanding dining room—the largest, according to Sanders, in any Buncombe County home, with the obvious exception of the Biltmore House.

The home was built by slaves, and Sanders said they dug the west end of Baird Bottom (which is now Beaver Lake—the lake was created in 1923) for the clay to create the bricks for Reynolds Mansion:

> *Originally, the house was located on 1,500 acres, which included all three peaks of Reynolds Mountain all the way to Beaver Lake, and to the front of us would be the shores of the French Broad River. It was all apple orchards. Israel Baird, who was Daniel Reynolds's wife's father—her name was Susan Baird—he owned all these orchards. That 1,500 acres was her dowry when she married Daniel. His first son to inherit this house was William Taswell Reynolds. William married a woman named Mamie Spears, and she's of the Smith McDowell clan. William and Mamie had two sons here—John and Robert, who became Senator Robert Reynolds.*

Cabinet at Reynolds House Bed & Breakfast Inn featuring items related to the Hope Diamond and family photos of Senator Bob Reynolds; his daughter, Mamie; and Mamie's grandmother Evalyn Walsh McLean. *Photo by Marla Milling.*

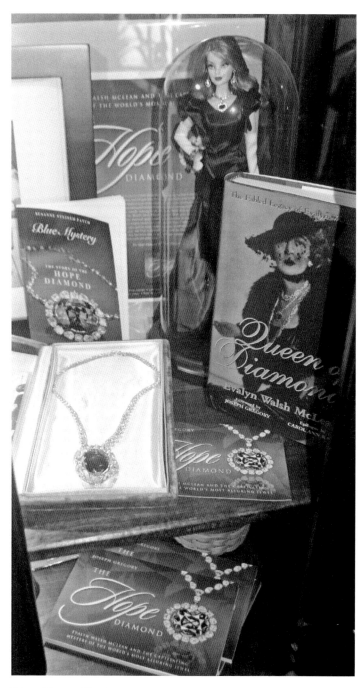

Hope Diamond books and other mementoes on display at the Reynolds Mansion Bed & Breakfast Inn. *Photo by Marla Milling.*

A photo of Mamie's mother, Evalyn McLean Reynolds, wearing the Hope Diamond. *Photo by Marla Milling.*

His Senate career is probably most remembered for how he fought to get the Blue Ridge Parkway to come through Asheville—it was originally planned to go through Tennessee.

Evalyn Washington McLean became the fifth wife of Senator Bob Reynolds in October 1941 at the fabulous Washington, D.C. home of her mother, known as Friendship. Sanders explained how the union happened: "There had been some tragedy in the family, and it was all rumored to be because of the curse of the diamond that she had. Her young daughter was nineteen, and she felt if she could marry her off to a father figure it might save her life. She told Senator Reynolds, 'If you will marry my young daughter, I will take care of you the rest of your life.' So the fifty-seven-year-old senator married the nineteen-year-old Evalyn. It was a business deal. They had a child [in 1942] whom he would name Mamie Spears Reynolds after his own mother." When Evalyn Reynolds took her life, Mamie spent a year living in the Reynolds Mansion with her governess, while her father carried out his last year of his political career in Washington. He then moved back to Asheville, and they took over the Reynolds-Oertling House—the one Joseph and Charles will soon call home. Sanders said it will be the first time any member of the Reynolds family has been a homeowner on Reynolds Mountain since 1972.

The legend of the curse is far removed from causing harm, it seems. Sanders said there's a show called *The Mysteries of the Hope Diamond*. "In it," he said, "they'll tell you that Mamie Spears Reynolds and Harry Winston are the only two people that the curse passed by because they never took possession of it." Mamie Reynolds died on November 15, 2014, at the age of seventy-two, and Harry Winston died in December 1978 at the age of eighty-two.

Biltmore Mystique

[Some of the missing books] *had been in the same location since my grandfather George W. Vanderbilt put them there in 1897.*
—*William A. V. Cecil*

More than likely, you're already familiar with George W. Vanderbilt's imprint on Asheville. After a trip to Asheville with his mother in 1888, he quickly scooped up 125,000 acres and hired the best artisans and environmental experts in the world to create his massive Biltmore Estate. He named it Biltmore from the Dutch town of his ancestors named Bildt and the English word *more*, which refers to rolling, mountainous countryside. It remains America's largest private residence, with 250 rooms, including a palatial dining room, a library with more than twenty-three thousand volumes, a bowling alley, a seventy-thousand-gallon indoor swimming pool and servants' quarters. But have you heard about the pink-haired heiress who left the estate in the hands of her estranged husband to follow her Bohemian whims? Or about the thief who pilfered valuable volumes from Vanderbilt's bookshelves? This chapter reveals more.

Biltmore House. *Special Collections, D. Hiden Ramsey Library, University of North Carolina at Asheville.*

Fun Facts About Biltmore House

- *175,000 square feet*
- *four main levels of the house, not counting the basement, sub-basement and attic.*
- *250 rooms*
- *35 family and guest bedrooms*
- *43 bathrooms*
- *65 fireplaces*
- *3 kitchens*
- *3 laundry rooms: Main Laundry, Brown Laundry (hand washing) and the Drying Room*
- *named a National Historic Landmark in 1963*

The Pink-Haired Heiress

Cornelia Stuyvesant Vanderbilt, the only child of George and Edith Vanderbilt, stands out as one of Asheville's most intriguing historical figures. Perhaps it's because her choices weren't always in alignment with her prominent status as heiress of her father's fortune, leading to a "hush hush" attitude about her chosen path post-Biltmore. Here's a brief capsule of Cornelia's life up to a point: She was born on August 22, 1900, raised at Biltmore House and traveled widely with her parents. She was a teenager when her father died in March 1914 following complications from an appendectomy. When she turned twenty-one, she received an annuity of $2 million; at age twenty-five, she received the principal sum of $50 million, bequeathed to her by her father. A year earlier, on April 29, 1924, in a lavish wedding in All Souls Cathedral in Biltmore Village, Cornelia exchanged vows with British aristocrat John Francis Amherst Cecil (pronounced *sess-ul*), who was ten years older. They invited 500 people to witness the nuptials at noon and increased the invitation list to 2,500 guests for a reception at Biltmore House. They had two sons, George Henry Vanderbilt Cecil (born in 1925) and William Amherst Vanderbilt Cecil (born in 1928), and the couple also helped stimulate the economy during the Great Depression by opening Biltmore House to paying guests in 1930. Admission was $2. Two years later, the Biltmore Company was formed to manage the estate.

In 1934, Cornelia and John divorced. She then fell off the public radar. It is curious to know what happened to Cornelia after she left Biltmore and why she never returned to the estate again. How could she simply walk away from the magnificent house and gardens created by her father and leave it in the hands of her estranged spouse? After the divorce, John Cecil spent most of his time at Biltmore until his death in 1954. He's buried at the Calvary Episcopal Church Cemetery in Fletcher, North Carolina. It's also curious that she married Cecil after news reports had claimed that she would only be willing to marry an American. Cecil hailed from the English town of Norfolk. He focused on history and international law at the New College of Oxford University and ultimately became a member of the British Diplomatic Corps. He served in several countries—Egypt, Spain and Czechoslovakia—before arriving in Washington, D.C., where he was named the first secretary at the British embassy. It was in Washington where he met Cornelia and began a romance with her.

There are details about Cornelia's motivation to flee Asheville that I won't be able to discern from the scant information available, but it could be that

The wedding of Cornelia Vanderbilt and John Cecil on April 29, 1924, in Asheville. *Library of Congress, Prints and Photographs Division, Washington, D.C., 20540.*

she needed the opportunity to freely pursue her own individual passions instead of just resting on the achievements of her family name. Or maybe she was searching for the type of happiness that money cannot buy. Or maybe she was just bored. An article titled "Cornelia Vanderbilt's Peculiar Love Problem," published in 1938 by American Weekly Inc., implies that Cecil's interest in the estate left Cornelia twiddling her thumbs. The article

Cornelia Vanderbilt. *Library of Congress, Prints and Photographs Division, Washington, D.C., 20540.*

notes, "Before marriage her days had been so full of the detail of managing the estate that she had hardly had time to think; but with Mr. Cecil taking over the cows and employees the usual outlet for her energy was abruptly cut off."

In digging for information about Cornelia, a variety of newspaper reports reveal hints of her Bohemian spirit. She apparently left Biltmore

to study art in New York City while living in Greenwich Village. One newspaper report noted, "She dyed her hair a bright pink, explaining that that was her proper color aura according to the findings of numerology. Also for numerology's sake, she changed her name to Nilcha." After a time in New York City, she traveled to Europe and reportedly engaged in a lengthy, complicated romance with a Swiss artist named Guy Baer. After her relationship with Baer ended, she enjoyed the interest of Captain Vivian Francis Bulkeley-Johnson. He was fifty-eight and she was forty-nine when they tied the knot on October 13, 1949, in a brief ceremony at the Kensington registry office in London, with only four witnesses present. Their entry into married life was a stark contrast to her all-the-frills first wedding to John Cecil. They reportedly lived a quiet life—she went by Mary—until his death on February 14, 1968. In 1972, she married her third husband, William "Bill" Goodsir. This time, she had fallen for a younger man. She was twenty-six years his senior. Cornelia died on February 7, 1976, at the age of seventy-five.

John Frances Amherst Cecil, husband of Cornelia Vanderbilt. *Library of Congress, Prints and Photographs Division, Washington, D.C., 20540.*

Brushes with Death

Cornelia's life also contains fortuitous changes in travel plans that led her and her family to escape tragedy. The first involved a trip she took with her parents, George and Edith. The second involved a flight her two sons, George and William, were supposed to take.

In 1912, George, Edith and Cornelia were booked on the maiden voyage of the *Titanic*. A week before they were set to leave, George abruptly canceled

their trip and rebooked for passage on the *Olympic*, which was departing Southampton a week earlier. Billed as "the ship that couldn't sink," the *Titanic* plummeted in the icy waters on April 15, 1912, after crashing into an iceberg. Of the 2,224 people on board, 1,514 died. Statistics reveal that almost 70 percent of the men traveling in first class perished in the sinking. Because of this, it can be speculated that if George Vanderbilt had been on board, he very likely would have died. The estate did suffer a loss in the *Titanic* tragedy, though: Mr. Vanderbilt's personal valet, Edwin Charles Wheeler (aka Fred), was on board the ill-fated ship as a second-class passenger.

The reason for the Vanderbilts' abrupt change from the *Titanic* to the *Olympic* is up for speculation. The *New York Times* published an article on April 30, 1912, claiming that Edith Vanderbilt's mother, Susan Dresser, persuaded the couple not to sail on a maiden voyage. This was debunked, however, because Mrs. Dresser died in 1883. Two other possible theories: George may have decided to sail on the *Olympic* to join his niece, Edith Shepard Fabbri, and her family, who were booked on the ship. Or the Vanderbilts may have worried about being delayed in the United Kingdom because of a continuing coal strike that was blamed for preventing some ships from sailing. Whatever the reason, it proved a stroke of good luck.

Then, in 1943, Cornelia's two sons were fortunately bumped off a plane flight. At the time, the Cecil brothers were headed back to England from their Swiss boarding school, but the VIP status of a movie star changed the plans. The star was Leslie Howard, who played Ashley Wilkes in *Gone with the Wind*. He was traveling with his manager, Alfred T. Chenhalls, and they took over the seats previously held by the Cecils. British Overseas Airways Corporation (BOAC) Flight 777-A took off from Portela Airport in Lisbon on its way to Whitchurch Airport near Bristol, England. It never made it. German forces shot down the plane over the Bay of Biscay.

Secret Storage

It's no secret that Vanderbilt collected priceless treasures from the world's top artisans and artists to fill his home, but for a short time during World War II, Biltmore became a secret repository for some of the most valuable holdings from the National Gallery of Art. If you've seen the movie *The Monuments Men*, you are aware of efforts during the war to preserve treasures and artifacts in Europe. Officials feared the possibility of air strikes in the

LEGENDS OF THE RICH AND FAMOUS

Trucks at Biltmore House, Asheville, preparing to return works of art to the National Gallery of Art after wartime storage, October 1944. *National Gallery of Art, Washington, D.C., Gallery Archives.*

United States, with Washington, D.C., a likely target. The new director of the National Gallery of Art, David Finley, worried about how to protect the treasures. As he brainstormed strategies, he remembered a previous visit to Biltmore as a guest. He contacted Edith Vanderbilt and received her approval to store sixty-two paintings and seventeen sculptures inside the house. The works stored there included a portrait of George Washington created by artist Gilbert Stuart, Titian's *Venus with a Mirror*, Raphael's *Portrait of Bindo Altoviti* and a self-portrait by Rembrandt.

Trucks carting the treasures pulled up to the front of the Biltmore House on January 8, 1942. Under heavy guard, the art was put into an unfinished room on the main floor for safekeeping. Workers secured the room by putting steel-vaulted doors in the archways and covering the windows with steel bars. Armed guards, hired by the National Gallery of Art, stood watch twenty-four hours a day. Tours at Biltmore continued through 1942, yet visitors had no idea that some of the world's most incredible artwork was secretly hidden on the other side of the wall. Of course, they were surrounded by

Vanderbilt's priceless collection, including paintings by such artists as Renoir and Monet, sixteenth-century Flemish tapestries and the amazing ceiling painting in the library that once adorned the Pisani Palace in Italy—*The Chariot of Aurora*, created by Giovanni Antonio Pellegrini. If guests noticed the guards, they most likely thought they were employed by Biltmore to protect the Vanderbilt's possessions. Gas rationing and a lack of manpower led Biltmore to shut its doors to tourists in 1943. It reopened on March 15, 1946. By then, the National Gallery of Art pieces were back in their rightful places in the nation's capital, having been returned in the fall of 1944.

As for that unfinished room, it's now open on the tour as the "Music Room." It opened to guests in June 1976, thirty years after playing a major role in the war effort.

Halloween Room

Recent research at Biltmore has revealed more about an unusually painted room in the basement that has been dubbed the "Halloween Room." The murals depict pictures of cats, bats, witches, intriguing figures and colorful scenes. For years, staff believed that the room was painted by guests at a 1920s Halloween weekend party. They've since learned the wall murals were created over a three-week period in December and connected to *La Chauve-Souris* (The Bat), which was an avant-garde Russian cabaret and theatrical troupe. The group performed in various venues across America in the '20s, including a stint on Broadway in 1922 and 1925. A researcher at Biltmore thought that the work in the Halloween Room resembled the artistry of Sergei Soudeikine and Nicolas Remisoff. Further investigation confirmed that these two artists did work for *La Chauve-Souris*. She compared their illustrations in the original cabaret program and found striking similarities to the murals at Biltmore. Once the artwork was complete, Cornelia and John Cecil hosted a gypsy-themed ball on December 30, 1925. The original paint of the murals remains on the walls at Biltmore, somewhat surprising since they were painted almost one hundred years ago.

Real-Life Mystery

George Vanderbilt's massive Biltmore House, with its hidden corridors and storied history, provides the perfect backdrop for a mystery. The Cecil family (Vanderbilt descendants who continue to own the castle) had no idea, however, that the filming of the movie *The Private Eyes* on the estate in 1980, starring Don Knotts and Tim Conway, would lead them searching for clues in a real-life whodunit. The movie was a Sherlock spoof, with Biltmore House posing as an English country mansion. Meanwhile, what could have been called "The Case of the Disappearing Books" was shaping up in real life. While touring the family library, said to hold more than twenty-five thousand volumes, an estate employee offered to show Conway a 1756 edition of Samuel Johnson's *A Dictionary of the English Language*, but it was nowhere to be found. Estate managers frantically called the Buncombe County Sheriff's Department when they discovered that the two-volume set, valued at $7,500, was missing. The loss didn't stop there. They inventoried the library and detailed a list of 234 missing items, including an $80,000 portfolio of Goya etchings; a 1797 copy of *The Book of Common Prayer*; Edmund Spenser's *The Faerie Queene*; volumes by Oscar Wilde, Lewis Carroll and the Brothers Grimm; and 781 collotype plates, circa 1797, published by Edward Muybridge as *Animal Locomotion* and valued at $100,000.

Local authorities called in the Federal Bureau of Investigation (FBI), and agents said they believed the case to be "one of the largest of its kind in the United States." As they questioned estate employees, they quickly keyed in on one person who stood out as a prime suspect. His name was Robert Livingston Matters (also known as Rustem Levni Turkseven). He had been working at Biltmore for about a year and a half as a night watchman. He also had another career, a job that raised the red flags for investigators. Matters owned the Plane Tree Book Store, an antique bookbinding shop, located at 12½ Wall Street in downtown Asheville. The Harvard grad ultimately pleaded guilty to four counts of interstate transportation of books, photographic plates and etchings and received a sentence from Asheville Federal Court judge Woodrow Wilson Jones of five years in prison and a $10,000 fine. The judge admonished him during sentencing, saying, "Your good education should have taught you what you did here was wrong. There is a price tag attached to violating the law."

FBI agents engaged the help of the Antiquarian Booksellers Association of Austin to help track down the pilfered books. They recovered items in bookstores in New York City and Los Angeles and located others in

William A.V. Cecil, grandson of George Vanderbilt, examines a volume from the Biltmore House library as FBI agent Robert Pence looks on. *From* Asheville Citizen-Times *archives, photo by June Glenn Jr.*

Europe, London and Canada. The 60 works initially recovered were valued at $300,000, but as William A.V. Cecil, owner of the Biltmore House, said in a January 1981 article in the *Asheville Citizen-Times*, the works were priceless because "they'd be impossible to replace." According to the book *Lady on the Hill*, it took more than two years to track down all 234 stolen volumes.

PART IV

SURPRISING CREATIONS

Beatty Robotics

He asked if I wanted to build something, and I screamed, "I WANT TO BUILD A ROBOT!"

—Camille Beatty

When Camille Beatty was twelve years old, she wasn't content to just appreciate the aesthetics of a new toy or electronic device; she wanted to know what was inside. She started taking things apart, examining their mechanics and quizzing her dad on what certain parts could do. "I'd bring a piece into my dad's office and say, 'Dad, what's this little green thing?' He would look at it, surprised that I had taken my toy apart and that it was now in pieces. He would try to identify it, and I just kept bringing him more and more and more things. I started taking apart clocks and remote controls just to see what was inside. It was like magic to me how it worked, and I wanted to figure out how they worked and in what ways."

Recognizing an opportunity to encourage her curiosity, Robert Beatty asked if she wanted to build something. "A robot," she screamed, and her ten-year-old sister, Genevieve, wholeheartedly agreed. Even though he encouraged their enthusiasm, he also tempered it with a dose of reality, telling them that building a robot would require a lot of time, patience and determination. Unfazed, the two Asheville-area girls pressed on and completed their first robot—modeled after a similar one in *Clone Wars*, which is a spin-off of the popular *Star Wars* series—within a few weeks.

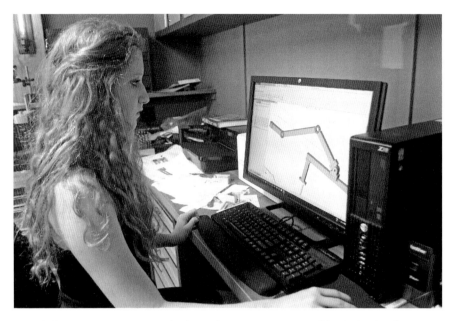

Camille Beatty plans out a new robotics project on the computer. *Photo by Marla Milling.*

"When we finished it, we said, 'Okay, what's next?' We started building robot after robot, finding different ways to design them and different ways to challenge ourselves," said Camille. "We were absolutely thrilled by the process and the results of what we could accomplish ourselves by just using little parts from Radio Shack."

Learning became a group effort. While Robert had a successful career in software and a current career as author of the wildly popular *Serafina* novels set at Biltmore Estate, he didn't know a lot about electronics, electricity, machining and putting components together. When they reached a stumbling block, they turned to YouTube videos and instructions they found online. "They would say, 'We need to connect these wires together,' so the three of us would literally watch the YouTube video on soldering together and learn how to do it together," said Robert. "Very quickly Genevieve became better at soldering than I was. We learned together, but she had smaller, steadier hands and could do it very, very well. One of the coolest parts as a father, and I hope as daughters, is we were learning together. They were seeing their dad, who had been successful in other things, learn right along with them using the Internet as a tool." They began outfitting their garage as their robot center, and

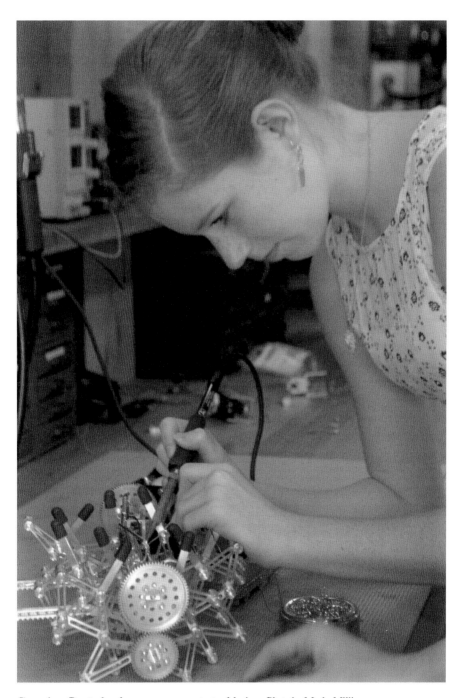

Genevieve Beatty has become an expert at soldering. *Photo by Marla Milling.*

as their expertise grew, they added more state-of-the-art equipment, allowing them to fabricate their own pieces.

Creating a blog at BeattyRobotics.com was the natural, parallel project to keep others updated about their creations. They began posting pictures and updates about what they were working on. The intended audience of family and friends enjoyed the blog, but other people were also paying attention, something they really didn't expect. They began fielding questions from others and freely provided full information on their blog about where they got their parts, how they learned to build robots and what they were designing next. Then a real shock came—a call from the New York Hall of Science, which wanted the trio to build a replica of the Mars Rover.

"A New York museum was asking us for a robot," said Camille. "And this robot is going to have to function throughout the entire day with children of all ages coming and messing with the controls. So, we had to challenge ourselves in a new way. We couldn't have an intermittent working robot. It needed to be functional every single day, every single time."

They successfully completed their Mars Rover and installed it in the museum on June 8, 2013. From there new opportunities continued to snowball—they were invited to the Maker Faire in New York City, where

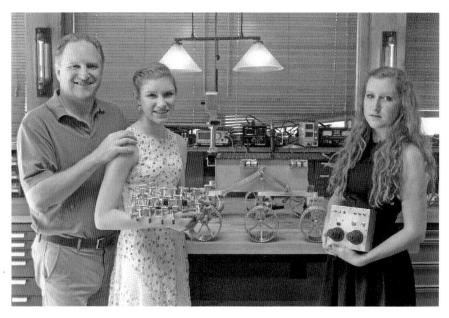

Author Robert Beatty with his enterprising daughters, Genevieve and Camille. They've built a robotics company in their garage. *Photo by Marla Milling.*

they won the Editor's Choice award, as well as attention from the director of NASA. "Here's the director of NASA at this event, and I was super excited," said Camille. "He comes over to me and asks to take a selfie with me because he's excited to see me. Here's the huge top guy, and he's nervous to ask me to take a selfie." Robert added, "The director of NASA wrote a letter of commendation and sent a big poster of the real Mars Rover, and all the engineers at NASA signed it and sent their congratulations."

Recognition also came from President Obama during the inaugural White House Maker Faire on June 18, 2014. A press release on the White House website included the president's remarks at the faire, which included a call out to Camille and Genevieve. In part, Mr. Obama said:

> *Camille and Genevieve Beatty are here today from Asheville, North Carolina. They're 14 and 12 years old. They happen to be the co-founders of Beatty Robotics. Genevieve does the wiring; Camille machines the metal. As their website puts it, "Who needs a paper route when you can start a robotics company?" That's a pretty good motto. That's great, I love that. But the Beattys say one of the main things they've learned over the last few years isn't about power tools or engineering or electronics. What they've learned is that, "If you can imagine it, then you can do it—whatever it is." And that's a pretty good motto for America.*

Pretty heady stuff for any robot maker, but especially for a couple of teenagers who fell into worldwide acknowledgement of their talents simply because they followed a dream, and it's a dream that continues to expand. At this writing, Camille is sixteen and Genevieve is fourteen. They speak with confidence and maturity yet have maintained a down-to-earth attitude and genuine thrill mixed with a touch of disbelief at what they've accomplished. Some of the other highlights of their growing robotics career includes creating a Lunokhod Lunar Rover (1969-era Russian Lunar Rover) for a space museum in Prague, three mini Mars Rovers for a hands-on museum exhibit in Europe and for two science centers in Kuala Lumpur and the list goes on. Their blog details each robot with pictures, videos and detailed descriptions.

"We thought we'd reached the pinnacle," said Robert. "We've done work for the New York Hall of Science and other museums all over the world. We were invited to the White House. We thought, 'We're done.' Then we got a call from the U.K. [in the spring of 2016], and this small space company wanted to partner with us to put a lunar rover on the moon. I don't know

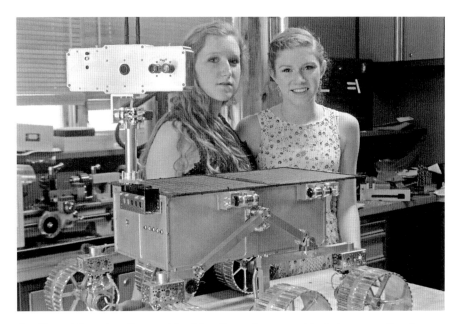

Camille and Genevieve Beatty with a Mars Rover they created in their garage. *Photo by Marla Milling.*

if they'll get the funding to create the rocket they need. There's a lot of 'ifs' in there, but it's fun to be involved in a real space program and it's great experience for the girls."

Camille has also become a sought-after speaker. She was invited to a conference in Rhode Island to talk about the robots to a group of seven hundred CEOs, university deans and other leaders. Camille, who is proficient in Spanish, was also invited to Madrid, Spain, to join a worldwide consortium on the effects of artificial intelligence and robots on the global work labor force and job market. Participants included twenty-five experts from around the world—people like the head of artificial intelligence for IBM, the head of the Israeli economy, the head of the Singaporean economy and Camille. "It was United Nations–style with black tablecloths and a U-shaped tabled and microphones and notepads," said Camille. "My dad was like, 'Where's my chair?' They said, 'You can sit behind her.'" "So I was the dad escort, nothing more," laughed Robert.

SPECTACULAR BOOK CREATIONS

Taking actions on dreams and moving them into the reality phase isn't new in the Beatty household. The father-daughters team was very much in play when Robert began working on a novel about a young girl named Serafina who lives in the basement of Biltmore Estate. He writes in a studio above the garage where they have the robotics equipment. He did write the first book in the main house, but now that the youngest Beatty daughter is four and very active, he finds he needs to leave her in the care of his wife as he retreats into solitude to craft his novels. *Serafina and the Black Cloak* debuted on July 14, 2015, and enjoyed twenty weeks on the *New York Times* bestseller's list. *Serafina and the Twisted Staff* came out on July 12, 2016, to rave reviews and also was a hit on the *New York Times* bestseller's list. Robert is currently at work on the third story in the series.

Camille and Genevieve were instrumental in the creation process from concept to finish. The Beattys had long enjoyed excursions at Biltmore, and once Robert identified Vanderbilt's massive house as the setting for his children's novels, the family began looking at the place with new eyes. "I'd go around the house with my girls and we'd say, 'Oh, this is a neat spot in here,' and we'd try to envision how Serafina would interact with that spot. Like she's being chased by the man in the black cloak, and she says, 'Should I hide in the rotisserie kitchen?' or, 'Should I hide in the hanging pots?' or, 'Should I hide in the sheets here in the laundry room?' We would go around together and try to envision Serafina's world while we were standing in it. We had particular interest in any doors or passages that were hidden or concealed."

The girls also kept Robert motivated. They would race home from school, hungry to hear the latest chapter. If Robert had failed to produce that day, they would say, "We've been at school all day. What have you been doing?" They loved hearing how he progressed the story of Serafina and even tossed in their own ideas. "We would sit together and I would read it to them, and as I was reading, they would say, 'Ooh, what if she did this?'" said Robert. "A lot of their ideas are in the story. It encourages them to make even more suggestions because they know I'm actually using the material. They also helped with how she talks and how she reacts and what she would be thinking about—that she'd be nervous when she saw Braden, things like that."

Robert also says that his exploration has led him to discover new details—things that most people would never notice on a routine trip through the magnificent house:

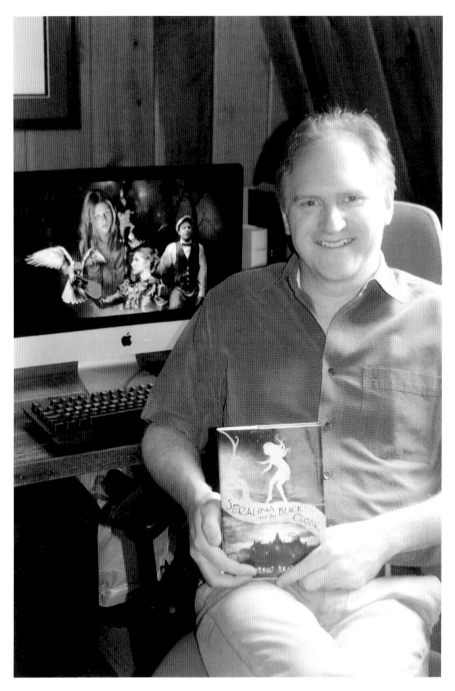

When Robert Beatty isn't helping his daughters build robots, he channels his creativity into novels. He's written the wildly popular *Serafina* novels, which are set at Biltmore Estate. *Photo by Marla Milling.*

One of the elements that is somewhat important to the story because of what Serafina is—you don't notice it, but there are depictions of cats throughout Biltmore. I've never heard of them owning cats. They owned dogs. I've never seen any indication that they were cat lovers or that they had cats roaming around the house. But the cats are depicted all over the place. There are two lions as you walk in. There's a big cat on the doorbell—it's a lion's mouth and the actual button is in its mouth. Pick any room—let's say the Billiard Room, there are three bronze statutes of lions and lionesses along the mantel. You go into the Breakfast Room and there's rampant lions up above the fireplace. Up on the third floor, there's a statue of a leopard attacking something. We find it interesting given Serafina's heritage that there are cats everywhere sort of hidden at Biltmore.

The idea to use Biltmore as a setting was conceived during a specialty tour Robert took into the basement and subbasement of the house. "Because of my technical background, I had particular interest in the electric dynamo and how they generated electricity and how interesting a period that was at the time, so I decided to make Serafina's pa the maintenance man who is in charge of keeping the dynamo running. And, of course, an evil man comes along and wants to make sure it's not running so that it's dark at night in the house. That's where the original idea started, based on my interest in an old type of electrical engineering and how they did things back in the day."

Robert has great appreciation for the advances Vanderbilt brought to Western North Carolina, as well as an appreciation for the Cecil family, the Vanderbilt heirs who operate the estate today. "My purpose in all of this was to honor Biltmore," he said. "I love Biltmore."

Groovy Garb

To my husband, it was a business venture; to me, it was magical.
—paper dress designer Audie Bayer

A simple advertising gimmick led to one of the hottest fashion trends of the 1960s: disposable dresses. Scott Paper Company revealed a throwaway dress in 1966 called the "Paper Caper" to launch its new "Color Explosion" line of toilet paper and paper towels. By mailing in $1.25, customers could receive a sleeveless, collarless A-line shift dress made out of a sturdy fiber paper called Dura Weave that Scott patented in 1958. It was 93 percent paper-napkin stock reinforced with rayon webbing. The dresses came in four sizes and two designs: a black-and-white Op art print and a bright orange-red paisley pattern. The purchase included a bonus envelope of coupons for Scott paper products. The inner label warned, "Paper Caper by Scott IMPORTANT: Your Paper Caper is fire resistant, but washing, dry cleaning or soaking will make the fabric dangerously flammable when dry." Advertising focused on the carefree nature of a disposable item, noting, "Won't last forever…who cares? Wear it for kicks—then give it the air."

What happened next would make any ad executive green with envy: women across the country just *had* to have a paper dress. Within six months, the company sold 500,000 paper dresses. Overwhelmed, Scott officials abruptly pulled the plug on the promotion, saying they did not want to turn the company into a dress manufacturer. This retreat paved the way for other companies to fill the demand for the paper dress frenzy. One of the major

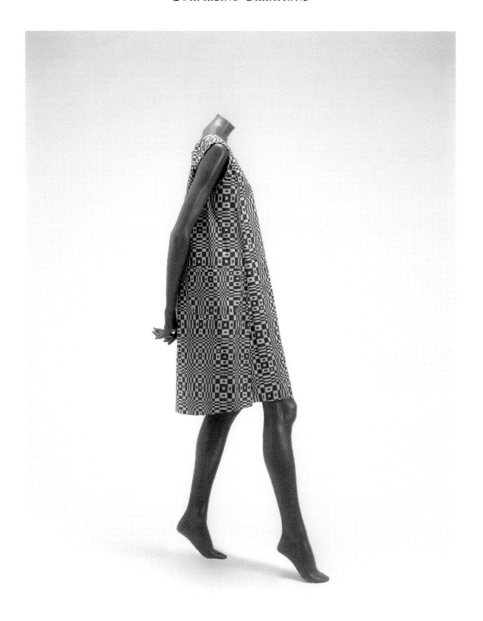

Paper Caper dress by Scott, which sparked a big fad in paper dresses in the 1960s. *Indianapolis Museum of Art.*

players was Mars Manufacturing, based in Asheville. At the peak of the fad, Mars Manufacturing churned out 100,000 dresses per week; most retailed between $1.99 and $3.99.

"My wife and I were the originators and manufacturers of the Waste Basket Boutique line of paper dresses and related disposable clothing," said Bob Bayer. "Abraham & Straus asked our permission to use the name Waste Basket Boutique for a separate department in all their stores."

Bob's wife, Audrey ("Audie"), was the daughter of Morry Bard, who opened Mars Hosiery Manufacturing in West Asheville in the 1940s. The plant produced women's hosiery, with seams running up the back, and then became the first company in the United States to produce panty hose. Audie left Asheville as a teen to attend Cornell University, and she met her soul mate, Bob, in her second week at college. They eventually married and returned to Asheville. Her father needed an engineer, which was Bob's chosen field, and they decided to see what contribution they could make to the family business.

Bob witnessed the declining profit margin in the hosiery business and turned his attention to disposable goods. He first focused on making disposable undershorts for army soldiers to wear in Vietnam. "We made a lot of samples and sent them into the field, but the material was not as sophisticated as it is now. It caused a lot of chaffing and would also cause little pieces of paper to fall down a guy's legs," said Bob. "Our real goal was to get into the medical market, but we knew the only way we'd get in would be to create a buzz through fashion. We started experimenting with paper dresses. When Scott launched their promotion, it gave us product recognition. We jumped right in. We were ready. The Scott thing was the impetus for us to carry on." Audie added, "We were at the right place at the right time and young enough to take a chance."

Audie studied English at Cornell, but with the company's new direction, she stretched her creative skills by designing the dresses—everything from choosing the paper prints to deciding on style and size along with the paper packaging. "There was a wallpaper printing company in Appleton, Wisconsin, and they sent us books of their discontinued designs," said Audie. "I had so much fun going through the pages and choosing prints to make A-shape dresses. Many were pop and mod; some were pretty wild."

Once the designs were selected, they were printed on their material and then shipped to Asheville for production. Hundreds of employees worked to cut and assemble the dresses and then package and ship. These were the days before Bob developed the automated machinery used for industrial and medical products. At that point, the machinery could cut, glue and assemble the product with a single employee at the end of the line to inspect and package.

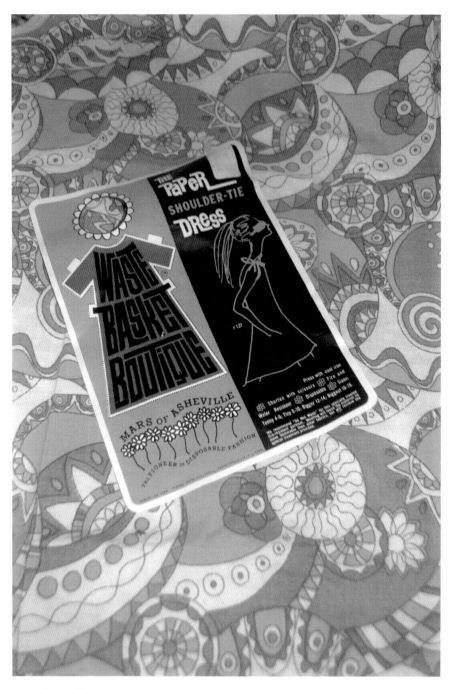

Waste Basket Boutique dress and packaging label, produced by Mars Manufacturing of Asheville. *Photo by Marla Milling.*

The dresses were packaged in plastic bags with a front cardboard insert decorated with their logo: a paper doll dress cutout with the words "Waste Basket Boutique" running across it. Above the dress is a circle cutout, where the doll's head would be, to display the dress print. Beneath the dress, it reads, "Mars of Asheville" above a row of daisies. Under the flowers, it reads, "The Pioneer in Disposable Fashion." The other side identified the style of garment along with the size guide: Teeny (4–6), Tiny (8–10), Bigger (12–14) and Biggest (16–18). It also gives instructions—press with cool iron, shorten with scissors, fire and water resistant—along with a "Do Not Wash" warning.

"The packaging was pretty corny, but it was not a sophisticated time," said Audie. "Today, you look at it and think 'oh my gosh,' but it's what sold. We did the packaging locally at Daniel's Graphics." The dresses caught the eye of editors at *Woman's Wear Daily*, which featured a picture of Mars Manufacturing disposable dresses on the front page along with an article.

Mars Manufacturing paper dress from the 1960s. *Bob and Audie Bayer.*

Sales exploded. "We went to the National Notions Show in New York City about a month after the *Woman's Wear Daily* article came out," explained Bob. "The buyers went wild. They needed something to pep up that department. That's where we got our first orders—from department stores all over the country."

They were also in the premium promotion field, creating paper dresses for companies like Hallmark. Four times a year, Hallmark changed its design of a combo featuring a paper dress for a hostess to wear along with all the matching paper goods: cups, napkins and plates to be used at a party. They produced

One of the paper dresses created by Mars Manufacturing of Asheville. *Bob and Audie Bayer.*

dresses and other items for presidential campaigns and corporations like Master Charge. "We were at a restaurant in Asheville when I first heard about this new concept of a charge card," said Bob. "[MasterCard] was

called Master Charge at that time, and we made a Master Charge dress as a promotion to kick off their new card."

Their biggest success was a paper dress with a Yellow Pages print. A one-page ad appearing in *Parade* magazine featured a model wearing the dress paired with bright-yellow tights. The headline reads, "Wear the Yellow Pages Out for $1." The ad continued to say, "What's black and yellow and read all over? The Yellow Pages Dress! It's wacky, wild, wonderful. A flashy paper put-on that's just plain fun to wear. We'll send your Yellow Pages Dress to you just about long enough to cover your knees—then with a pair of scissors you can cut it to any length you like." Customers cut out the coupon, filled in their address and then mailed it with their one dollar (postage included) to a PO Box in Asheville.

Two days after the ad ran, they received about five thousand envelopes. "The next day, we received twenty-five thousand. The next day, fifty thousand," said Bob. "We were overwhelmed with two secretaries." They solved the problem by hiring Daniel's Graphics to provide redemption services.

With the overwhelming demand for paper dresses came unexpected fame. The Bayers appeared on the TV shows *To Tell the Truth* and *What's My Line?* and witnessed their company and products featured on *CBS Evening News*, on the front page of the *Wall Street Journal* and in many other publications, including *Parade*, the *London Times*, the *New York Times*, *Business Week* and *Forbes*. They were also amazed at a spread that *Vogue* magazine created featuring their products. "They started out with a full-page photo showing a model wearing one of our paper jumpsuits," said Audie. "When you opened it up, there were three or four pages about the company and the dresses." Bob added, "For Audie, who was a liberal arts major, to get this level of recognition as a designer is incredible."

Audie admitted that paper dresses were uncomfortable to wear, and she says she still finds it very interesting that people bought them. While she didn't wear the dresses often—she says she never saw anyone in Asheville walking down the street in a paper dress during that time—she does have a fun memory of wearing one of the evening gowns she designed. "We had been experimenting with a company coating paper with metallic," she said.

> *I made a long silver evening gown. Grove Park Inn used to close in the winter, but they would have a big fancy ball dance on New Year's Eve and fire up the big fireplaces. I took one of our long silver foil dresses and bought some silver drapery trim and sewed it around the neck. That was fun. In some real high society benefits for museums in New York City, the invitation*

would be a paper dress. It was sent out as an invitation to benefactors, and they were told to decorate the dress in any way they wanted. Some took them to famous designers, who added features and plumes and beading. Women were trying to outdo each other. That really cracked us up that they were putting all that money into a $1.99 dress. Pretty frivolous.

Audie also enjoyed the "paint your own" dresses they produced—plain white dresses with paint to make your own design. These were popular for little girls at birthday parties, but Audie remembered a party where the adults enjoyed their own brand of creativity. "Every woman there put on a white paper dress, and their husband decorated the dress while it was on her," she said. "Everyone had a few drinks, and it really got graphic."

Famed pop artist Andy Warhol decorated a paint-your-own paper dress with the word *Fragile* displayed on it. That dress is among holdings at the Brooklyn Museum. At the time, Warhol didn't have any name recognition. "There was a store in Brooklyn called Abraham & Straus. They said a new, hot, unknown pop artist was going to be at the opening of their Waste Basket Boutique, and he was going to be decorating some dresses. We didn't think it was important enough to go," said Audie.

The saying "All good things must come to an end" held true for the paper dress industry. The trend fizzled out, putting smaller manufacturers out of business. But Bob Bayer was prepared. "So many people were saying, 'It's phenomenal, but it's going to end,'" said Audie. "I give Bob credit for quietly planning what would happen next." He refocused attention on industrial and medical disposables, but it wasn't a quick, easy sell to doctors, who were fixed in their belief that cotton was better. "The operating nurses were the ones who were our champions," said Bob. "They wanted the product. They went back to their chiefs of staff and helped push it. They were our salespeople."

The Bayers sold Mars Manufacturing in 1970 to Work Wear Corporation. After that, they founded American Threshold Industries on Sardis Road (the building now houses Industries for the Blind) and focused on producing disposable hospital and laboratory products. They retired when they sold this company in the late 1990s. They donated their collection of paper dresses and other paper garments to the Asheville Art Museum. They also donated much of the ephemera—advertising, newspaper articles and other printed information—to the Special Collections at D.H. Hiden Ramsey Library at the University of North Carolina–Asheville.

Bibliography

Albuquerque Journal. "Are Billy the Kid, Pat Garrett in Tintype?" December 6, 2015.

Ambassador. "Shining New light on the Halloween Room" (Fall/Holiday 2016). Newsletter mailed from Biltmore Estate.

American Weekly. "Cornelia Vanderbilt's Peculiar Love Problem." 1939.

Asheville Citizen-Times. "Asheville's Central Landmark, Vance Monument, to Be Fixed." March 11, 2015

———. "Black History Emerges from 1897 Time Capsule: Only Known Copy of a Black Newspaper Has Been Concealed for More than a Century." June 6, 2015.

———. "Book Theft Nets Five-Year Term." March 3, 1981.

———. "City Unearths Time Capsule Beneath Vance Monument." March 31, 2015.

———. "Dear Future: A Letter from 2015 and Asheville Past." September 18, 2015.

———. "Flea Market Find May Be Valuable Billy the Kid Photo." January 7, 2016.

———. "Lombardi Sweater Found in Asheville Sells for $43,020." February 22, 2015.

———. "Memphis Belle: Plane Good Movie, Former Pilot Says of High-Flying Film." October 7, 1990.

———. "New Asheville Time Capsule Ready to Go Underground." September 12, 2015.

Bibliography

———. "Plea Filed; Rare Books Recovered." January 1981.
———. "Request Reveals Biltmore Book Theft." January 13, 1981.
Asheville Times. "Asheville Grandchild's 25th Birthday to See McLean Fortune Split." May 1, 1947.
ATOPOS. "RRRIPP!! Paper Fashion" (2007).
Carolina Public Press. "Previously Unknown Photo Album of Asheville in 1904 Surfaces." January 15, 2015.
Charlotte Observer. "Reynolds 'Has All' He Wants." July 10, 1955.
Daily Mirror. "Leslie Howard Is Lost in Air Liner Shot Down by Nazis Over Bay of Biscay." June 3, 1943.
Defense Media Network. "The Shutdown of Leslie Howard: The Death of a 'Gone with the Wind' Star." June 20, 2013.
Des Moines Register. "One Vanderbilt Heiress Who'll Have Only an All-American Husband." November 6, 1921.
Fahrer, Sharon C. *A Home in Shalom'ville: The History of Asheville's Jewish Community*. N.p.: History@Hand Publishing, 2015.
Good Magazine. "Who Killed Paper Clothing?" December 28, 2015.
Hendersonville Times News. "The Vanderbilts' Close Call with the Titanic Tragedy." April 8, 2012.
Milwaukee Sentinel. "Romantic Rebels: Every Precaution Was Taken to Give Cornelia Vanderbilt Simple Tastes, Yet She Became One of the Most Defiant and Least Conventional Members of Society." January 1, 1950.
———. "Strangely Similar Troubles of the Two Pink-Haired Vanderbilt Beauties." February 23, 1941.
———. "Strange Matrimonial Disaster of Cornelia Vanderbilt." July 29, 1954.
Mountain Xpress. "Diamonds and Drugs, Guitars and Guns." July 27, 2005.
———. "Fun While It Lasted." July 11, 2007.
———. "Here's to the Next 100 Years: Asheville Installs Time Capsule in Vance Monument." September 15, 2015.
Newsmax. "Amelia Earhart Latest Theory Recasts Her as Just a Castaway." September 16, 2016.
North Carolina Historical Review 73, no. 3. "Chariots of Wrath: North Carolinians Who Flew for France in World War I" (July 1996).
Smithsonian Magazine. "The Hope Diamond Was Once a Symbol for Louis XIV, the Sun King." January 28, 2014.
———. "New Analysis Strengthens Claims that Amelia Earhart Died as a Castaway." November 2, 2016.

BIBLIOGRAPHY

Walford, Jonathan. *Ready to Tear: Paper Fashions of the '60s*. N.p.: Kickshaw Productions, 2007.

Warren, Joshua P. *Haunted Asheville*. N.p.: Shadowbox Publications, 1996.

Index

A

Abrams, Christina 91
Abrams, Frank 90
Adler, Emma 37
Adler, Gus 37
Asheville ZombieWalk 53

B

Battle, Dr. S. Westray 43
Battle Mansion 42
Bayer, Audrey ("Audie") 154, 156, 158, 160, 161
Bayer, Bob 156, 158
Beatty, Camille 145, 150
Beatty, Genevieve 145
Beatty, Robert 146
Bennett, Mark-Ellis 35, 103
Billy the Kid 90, 92
Biltmore Estate 18, 130, 151
Biltmore House 139, 151, 153

C

Camp Patton-Parker House 72
Cecil, Cornelia Stuyvesant Vanderbilt 132
Cecil, Dr. DeWayne 55
Cecil, John Francis Amherst 132
Cecil, William A.V. 130, 135
Collider, The 55, 56, 57
Conway, Tim 139

D

Dark Ride Tours 48

E

Earhart, Amelia 54
Ellington, Douglas 123

F

Frazier, Kevan 30, 68

G

Garrett, Pat 92
Giavedoni, Sarah 53
Gillespie, Ric 54, 56
Gone with the Wind 136
Goodwill Outlets 18, 100
Graceland Auctions 112
Gregory, Joseph Charles McLean 18, 114, 121

INDEX

Gregory, Mamie Spears Reynolds 114, 118
Grove Park Inn 103

H

Harris, Debbie 107
Harris, Mike 107
Haunted Asheville 42
Helen's Bridge 46
Heritage Auctions 103
Hope Diamond 18, 114, 118, 124
Howard, Leslie 136

I

International Group for Historic Airline Recovery, The (TIGHAR) 54
Ivester, Debbie 64

J

Jackson Underground Café 34
Julien's Auctions 112

K

Knotts, Don 139

L

LaZoom 107
Lombardi, Vince 100

M

MacKenzie, Jimmy 53
Mars Manufacturing 18, 155, 161
Martinez, German 72
Mason, Barney 94
Masonic Temple 26
McCanless, J.M. 87
McEvoy, Rikki 100
McEvoy, Sean 100
McLean, Evalyn Walsh 18, 115
Memphis Belle 57
Menard, Lucy 82
Morgan, Robert 57
Muzzy, Florence 94

N

National Gallery of Art 136
Noonan, Fred 54
North Carolina Room at Pack Memorial Library 18, 28, 80, 82

O

O. Henry 47

P

Pack's Tavern 25
paper dresses 154
Patton, Thomas Walton 76
Porter, William Sydney. *See* O. Henry
Presley, Elvis 107
Private Eyes, The 139

R

Rapp, Chuck 120, 122
Rat Alley 25, 30
Reynolds, Evalyn McLean 114
Reynolds, Mamie. *See* Gregory, Mamie Spears Reynolds
Reynolds Mansion Bed & Breakfast Inn 45, 124
Reynolds-Oertling House 120, 123, 129
Reynolds, Senator Bob 18, 114
Rhine, Zoe 82
Riverside Cemetery 47
Rockwell, Kiffin 59
Root, Eddie F. 98
Root, Elihu 98
Rudabaugh, Dirty Dave 93, 94

S

Sanders, Billy 45
Serafina and the Black Cloak 151
Serafina and the Twisted Staff 151
Sevier, General John 19
Siemens, Jim 72
Smithsonian's Museum of Natural History 114
South, Heather 66

INDEX

T

Titanic 136

U

underground bathrooms 26, 28, 34
Upson, Ash 94

V

Vance Monument 26, 63, 70
Vanderbilt, Cornelia. *See* Cecil,
 Cornelia Stuyvesant Vanderbilt
Vanderbilt, George 18, 132, 151
Voyles, David 48

W

Walker, Chris 43
Warren, Joshua 25, 46
Waste Basket Boutique 158
Webb, Charles A. 71
Western Regional Archives 66
Winston, Harry 118, 129
WLOS-TV 43
Wolfe, Thomas 47

Y

Yoder, Karen 51

Z

Zambra 35

About the Author

Marla Hardee Milling is an Asheville native who loves writing about her hometown more than any other topic. The History Press published her first book, *Only in Asheville: An Eclectic History*, in June 2015. This is her second book.

She's a full-time freelance writer and serves as a contributing editor for *Blue Ridge Country* magazine, freelance staff writer for TheManual.com and freelance staff writer for Match. com. In addition, she writes frequently for the Asheville-based monthly magazine *Capital at Play*, *WNC Parent/ Asheville Citizen-Times* and other publications. More than eight hundred of her articles/essays have appeared in such publications as *Luxury Living*, *Our State*, *WNC*, *Smoky Mountain Living*, *Charleston*, *Denver*, *American Style*, *NICHE*, *Smart Computing*, *Christian Science Monitor*, *Parenting*, *Health*, *Redbook*, *ePregnancy*, *New Orleans Gourmet*, *PC Today*,

Photo by Suzie Heinmiller Boatright, photographybysuzie. smugmug.com.

About the Author

alumni magazines at UNCA and Western Carolina University, *Chocolate for a Woman's Soul II* and many others, as well as on Interest.com.

Milling is a member of the American Society of Journalists and Authors (ASJA) and has been self-employed as a full-time freelance writer since August 2004. She previously spent ten years as a news producer at WLOS-TV (ABC affiliate) in Asheville, North Carolina, and six years as director of communications at Mars Hill College (now University) in Mars Hill, North Carolina. She currently serves on the Board of the Friends of the North Carolina Room at Pack Memorial Library in Asheville.

Growing up in the Skyland area of south Buncombe County, she received a diploma from T.C. Roberson High School. She went on to earn a bachelor's degree in communications with a minor in political science from the University of North Carolina–Asheville. She lives in north Asheville with her two teenagers, Ben and Hannah, and four cats.

Her roots run deep in the Western North Carolina mountains, with ancestors on both sides going back for many generations.

Visit us at
www.historypress.net

This title is also available as an e-book